The Remembering Garden

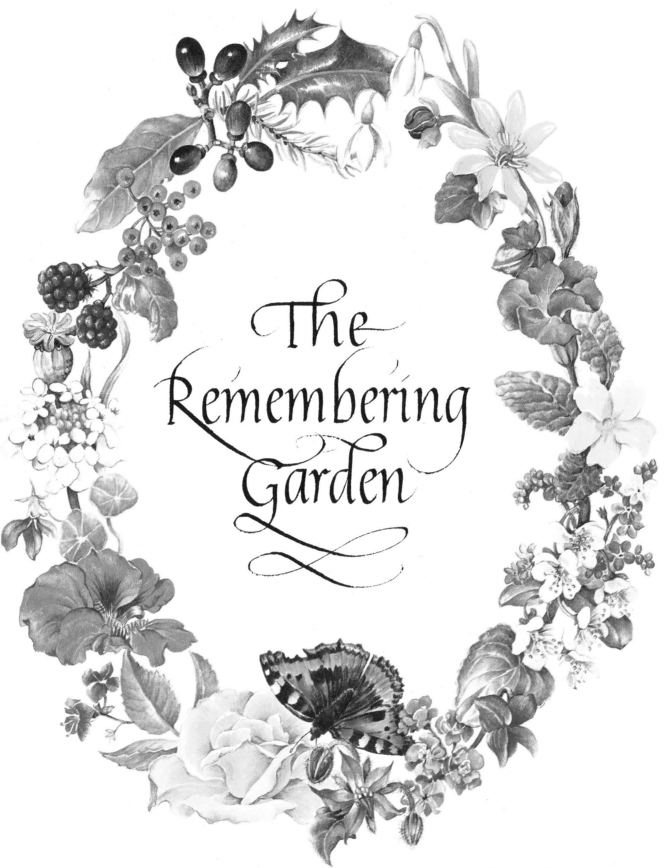

The Remembering Garden

ROSANNE SANDERS

Clarkson N. Potter, Inc./Publishers NEW YORK
DISTRIBUTED BY CROWN PUBLISHERS, INC.

to

CHARLIE

First printing

Layout and typography by Mike Spike
Printed in Italy by Arnoldo Mondadori Editore, Verona

First published in the U.S.A. in 1980 by
Clarkson N. Potter, Inc.,
Distributed by Crown Publishers, Inc.,
One Park Avenue, New York, N.Y. 10016

Published simultaneously in Canada by General Publishing Company Limited

Library of Congress Cataloging in Publication Data
Sanders, Rosanne.
The remembering garden.

1. Gardens–Pictorial works. 2. Flowers–Pictorial
works. 3. Nature–Poetry. 4. Gardens–England–
Pictorial works. 5. Seasons–Pictorial works.
6. English poetry. I. Title.
SB455.S29 1980 700'.942 80-16128

ISBN: 0-517-541696

INTRODUCTION

My love for the countryside began in childhood, when I would wander for hours, either on foot or on horseback, through the fields and beechwoods of Buckinghamshire. I did not appreciate how much this meant to me until years later when I was living in a small London flat, surrounded by buildings and streets with tired-looking trees that had been permitted to grow through allotted squares of pavement.

Throughout those years in the city I dreamed of having a garden of my own, a country garden, surrounded by fields and wild flowers, and freely growing trees. This book, begun purely for my own satisfaction, is an expression of the joy I felt in finally owning such a garden.

In 1976 my husband and I bought a small stone cottage in Devon. The landscape is very different from that of Buckinghamshire where I lived as a child, for Devon is a county of deep lanes bordered with high banks which in spring are covered with wild flowers. Primroses are an essential characteristic of Devon and, together with celandines, stitchwort and campion, followed by bluebells, wild garlic and the occasional early purple orchid, make the banks a pattern of colour wherever you go. The garden, really two separate gardens with the house in the middle, is situated on a gentle slope one mile from the sea, with a lane and wood running along one side. We are separated from the lane by a high bank that at the top of the garden widens out to about ten feet. Trees and shrubs have been planted there and this area is left for the wild flowers. Patches of nettles are also left to grow there, for many butterflies depend on the stinging nettle for food for their larvae.

Inside the bank at the top is the herb garden, where I have planted flowers and shrubs that are especially favoured by butterflies: aubretia, honesty, lavender, thyme, Michaelmas daisies and buddleia, to name but a few.

Along the top of the garden, cordons of apple and pear trees have been planted, in front of which is the vegetable garden, hidden from the house by flowering shrubs. All round, to the right of the house, are fields where the cows graze and sometimes stand with their great heads leaning on the wall watching us with soulful eyes.

On the other side of the house is the lower garden sloping downwards to the fields and bordered again by high banks. At the bottom of the slope are the flowering plum and purple crab trees, both of which look lovely when in blossom against the background of the wood.

We couldn't live in our cottage all the time at first but came down from London at every opportunity, sometimes for a week or two, sometimes just a weekend. Each time we were busy decorating or gardening; there was plenty to do, and after a year we were more or less settled. It was then that I had the idea of making a book of the garden, painting the flowers and wildlife as they appeared throughout the year.

I purchased a ready-bound book with blank pages and on the first day of the new year sallied forth to see what I could find. The snow lay thick upon the ground, the sky was grey and heavy and it seemed unlikely that anything would be flowering in such cold conditions. But some flowers, however delicate they seem, have great tenacity, and I found nine different flowers that day, pansies, polyanthus and heathers, and even a few branches of escallonia 'apple blossom' though this is a shrub that normally flowers in summer. I remembered where I had seen a group of primroses flowering before the snow came, and after carefully brushing away the snow, I recovered them, perfectly preserved.

I found a poem entitled 'January' which seemed to describe the grey and cheerless opening to the year, and having then set a precedent, I thereafter chose a favourite poem with a name for every month to set the scene for each section of the book.

January is far from being a dead month, more a month of suspended animation, which only needs a spell of crisp dry weather to bring it alive. In Devon, some January days come with almost Spring-like tenderness, enticing the flowers and insects from their winter sleep.

In spite of the cold air and leafless woods, one could already feel the stirring of new life and a sense of anticipation. The snow quickly disappeared and snowdrops were soon pushing their green spikes through the cold dark earth. How pure and delicate they seemed, those white harbingers of spring.

On the 6th February, I found a lone celandine flowering on the bank, its bright yellow petals shining out from the rosette of dark green leaves.

It was now the time of year for planning the summer garden. The seedsmen with their dazzling catalogues make it almost impossible to resist creating a fantastic garden in one's mind and I fell, a willing victim, into the trap, ordering far too many seeds. In March the seeds that I had ordered arrived, and I found Muriel Stuart's poem 'The Seed Shop' to include in the book.

During that month, the neighbouring farmer decided to fell the trees that separated two fields beyond our lower garden, and I could hear the sound of the chain-saw screaming through the air time after time. The stream which ran alongside the trees was piped underground and the little valley was filled in with lorry-loads of earth. Once the fields were green again and the stillness returned, we were able to adjust to the new outlook, but it saddens me still to remember the graceful silhouette of the ash tree at dusk, the sound of the little stream and the singing of the birds in that hedgerow copse. Edward Thomas's poem 'First Known When Lost' describes this perfectly.

By now the spring flowers were out and new life was everywhere. We planted several trees in both parts of the garden to try to compensate for those that had gone from the field. The garden was vibrant and exciting, one could almost see things growing: it was a 'Reawakening' indeed.

In May the wood is a misty carpet of bluebells and the trees stand like sentinels holding up their canopy of fresh green leaves. The butterflies are in greater numbers: Orange Tips, Small Tortoiseshells, Peacocks, Common Blues and Red Admirals can all be seen on warm sunny days.

April and May is a very busy time of year. Spring bedding plants have to be moved to make way for summer bedding, the grass grows so quickly that the lawn needs cutting again almost as soon as it is mowed, and the weeds grow faster than anything else. Seeds are sown, seedlings are pricked out, grown on and hardened off ready for planting, and there is a never-ending list of jobs to be done.

I continued throughout the summer, painting and cataloguing the plants, and choosing poems to enhance the mood of the garden. We were still living in London and the gardening and paintings had to be completed during visits that were all too short. I painted as many flowers and creatures as I could, sometimes working far into the night to finish a toad or a group of flowers. We were lucky enough to have a neighbour who had lived nearby and worked in the garden for over thirty years. He was always on call for advice and took care of everything during our absence.

The wild roses and honeysuckle now took over the banks and hedgerows and in the lane the bracken fronds on each side almost met one another. The garden was filled with heavy scents and the drowsy hum of bees, and at dusk bats could be seen flitting across the evening sky. How hard it was to tear ourselves away from the garden at such times and return to the city.

Soon August came and the evenings started drawing in. The floral season was already beginning to decline, and local enthusiasts were busy making preparations for the flower show. Flowers ripened into fruit, the corn turned golden yellow, and the dahleas now took over the lower garden.

As summer turned into autumn, it was time for our migrant visitors to depart; house martins and swallows lined the telegraph wires and all too soon were gone. The sky seemed empty without them.

We made frequent visits to the farm to help with the harvesting, after which we would be invited to share an enormous tea in the farmhouse.

The fruit was collected and put into store for the winter; the onions were strung up in bunches and hung from the roof of the shed; fruit was gathered and made into jam, elderberries into wine, sloes into sloe gin, and the leaves turned colours varying from yellow to vermilion, and gradually dropped off the branches.

As the year wound through its full cycle, the garden prepared for winter sleep. The butterflies came indoors and found crevices and corners in which to hibernate, the toads crawled under stones and the hedgehogs returned to their nests.

December seems to be the month of the evergreens. The holly tree outside the back door was luxuriant with dark shining leaves and clusters of red berries and the bay tree, laurel bushes and ivy all seemed to come into their own. We were in Devon for Christmas and we decorated the house with bunches of holly and bay. I was given a very fine azalea, which I painted on the last page of the book, and on Christmas Eve we walked down our little lane to the village church where we attended Midnight Mass.

I can only hope that you who read and look at these pages will also find there some of the joy and peace of mind that I experienced during this year in my country garden.

THE REMEMBERING GARDEN

HE brought me into a deep remembering garden;
And I was like one that wakes from
a dream of pain
To hear the cry of a thrush in the woods
at evening,
And the sound of a brook, and the
whisper of Eden again.

He drew me out of the throngs of the fog-bound city;
And, if they forget my songs, and the
fond dreams die,
It will not be the only forgetting while,
here in the stillness,
The sea breathes low, and the high stars
wake in the sky.
For it is not true that the wonder is lost in childhood;
It is not true that, in manhood, the
music is gone;
It is not true that the soul is mocked
by its maker;
When the high priest sneers in its face,
and the night draws on.

Alfred Noyes.

JANUARY

flowers found
in the garden
on January 1st

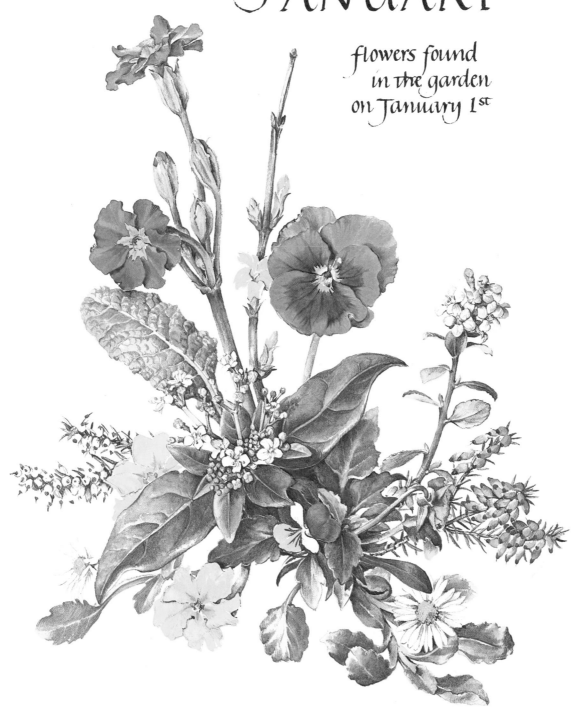

JANUARY

COLD is the winter day, misty and dark:
The sunless sky with faded gleams is rent:
And patches of thin snow outlying, mark
The landscape with a drear disfigurement.

The trees their mournful branches lift aloft;
The oak, with knotty twigs is full of trust,
With bud-thronged bough the cherry in the croft;
The chestnut holds her gluey knops upthrust.

No birds sing, but the starling chaps his bill
And chatters mockingly; the newborn lambs
Within their strawbuilt fold beneath the hill
Answer with plaintive cry their bleating dams.

Their voices melt in welcome dreams of spring,
Green grass and leafy trees and sunny skies:
My fancy decks the woods, the thrushes sing,
Meadows are gay, bees hum and scents arise.

And God the Maker doth my heart grow bold
To praise for wintry works not understood,
Who all the worlds and ages doth behold,
Evil and good as one, and all as good.

Robert Bridges

Flowers of January

Lone Flower, hemmed in with snows, and white as they,
But hardier far, once more I see thee bend
Thy forehead as if fearful to offend,
Like an unbidden guest. Though day by day
Storms, sallying from the mountain-tops, waylay
The rising sun, and on the plains descend;
Yet art thou welcome, welcome as a friend
Whose zeal outruns his promise! Blue-eyed May
Shall soon behold this border thickly set
With bright jonquils, their odours lavishing
On the soft west-wind and his frolic peers;
Nor will I then thy modest grace forget,
Chaste Snowdrop, venturous harbinger of Spring,
And pensive monitor of fleeting years!

William Wordsworth.

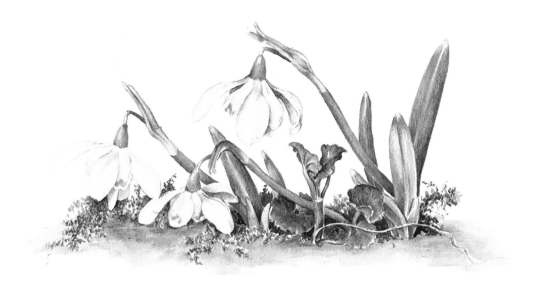

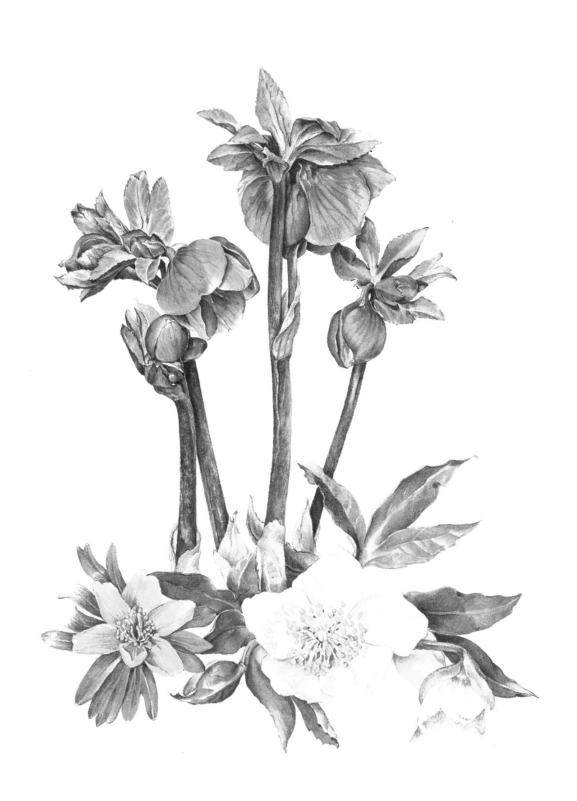

FEBRUARY

ONE MONTH IS PAST another is begun
Since merry bells rang out the dying year,
And buds of rarest green began to peer
As if impatient for a warmer sun,
And though the distant hills are bleak and dun
The virgin snowdrop like a lambent fire,
Pierces the cold earth with its green streaked spire
And in dark woods the wandering little one
May find a primrose.

February 1st 1842. Hartley Coleridge.

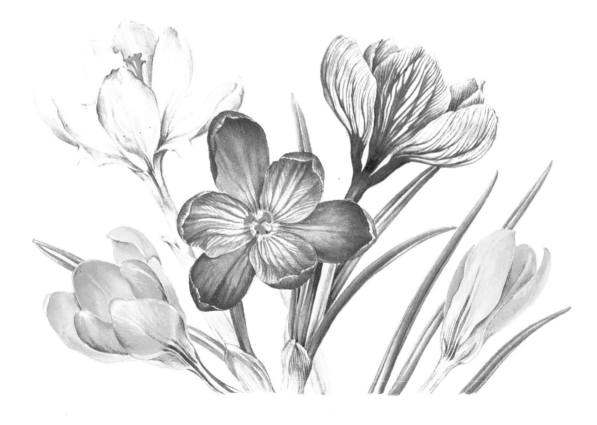

SHE found the celandines of February
Always before us all. Her nature and name
Were like those flowers, and now immediately
For a short swift eternity back she came,
Beautiful, happy, simply as when she wore
Her brightest bloom among the winter hues
Of all the world; and I was happy too,
Seeing the blossoms and the maiden who
Had seen them with me Februarys before,
Bending to them as in and out she trod
And laughed, with locks sweeping the mossy sod.

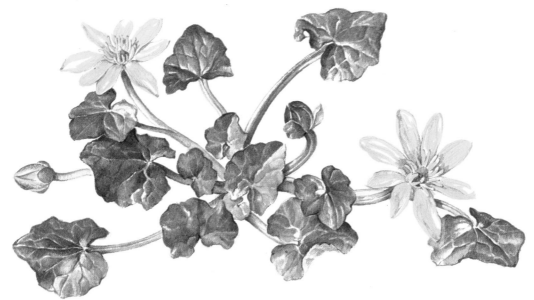

But this was a dream: the flowers were not true,
Until I stooped to pluck from the grass there
One of five petals and I smelt the juice
Which made me sigh, remembering she was no more,
Gone like a perfectly recalled air.

Celandine: Edward Thomas.

—SO IN WINTER

The gardener sees what he will never see.
Here, in his lamp-lit parable, he'll scan
Catalogues bright with colour and with hope,
Dearest delusions of creative mind,
His lamp-lit walls, his lamp-lit table painting
Fabulous flowers flung as he desires.
Fantastic, tossed, and all from shilling packet
—An acre sprung from one expended coin—
Visions of what might be.

The Garden : V. Sackville-West.

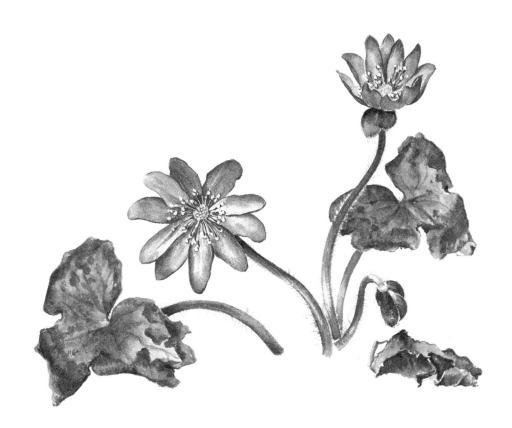

FIRST KNOWN WHEN LOST

I never had noticed it until
'twas gone, — the narrow copse
Where now the woodman lops
The last of the willows with his bill.

It was not more than a hedge overgrown.
One meadow's breadth away
I passed it day by day.
Now the soil is bare as a bone,

And black betwixt two meadows green,
Though fresh-cut faggot ends
Of hazel made some amends
With a gleam as if flowers they had been.

Strange it could have hidden so near!
And now I see as I look
That the small winding brook,
A tributary's tributary, rises there

An Epitaph to the trees.

Edward Thomas.

MARCH

With rushing winds and gloomy skies,
The dark and stubborn winter dies;
Far off, unseen, Spring faintly cries,
Bidding her earliest child arise..

March: Bayard Taylor

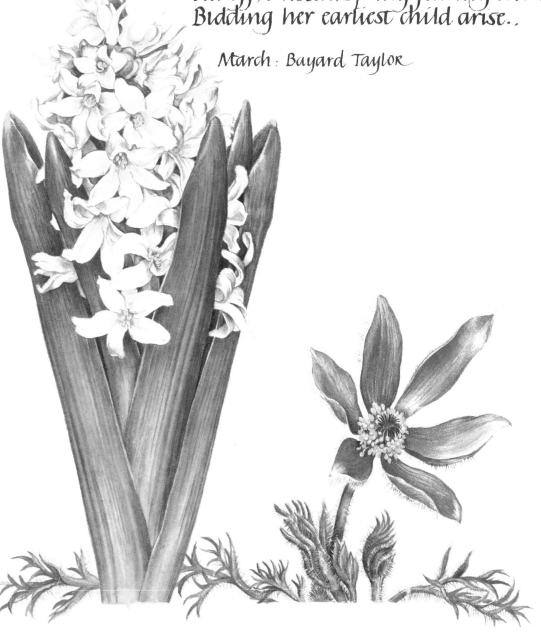

HERE in a quiet and dusty room they lie,
 Faded as crumbled stone or shifting sand,
Forlorn as ashes, shrivelled, scentless, dry—
Meadows and gardens running through my hand.

In this brown husk a dale of hawthorn dreams,
A cedar in this narrow cell is thrust;
It will drink deeply of a century's streams,
These lilies shall make summer on my dust.

Here in their safe and simple house of death,
Sealed in their shells a million roses leap;
Here I can blow a garden with my breath,
And in my hand a forest lies asleep.

The Seed Shop: Muriel Stuart.

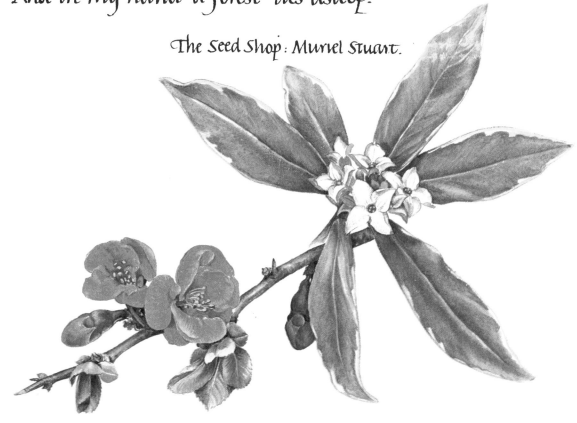

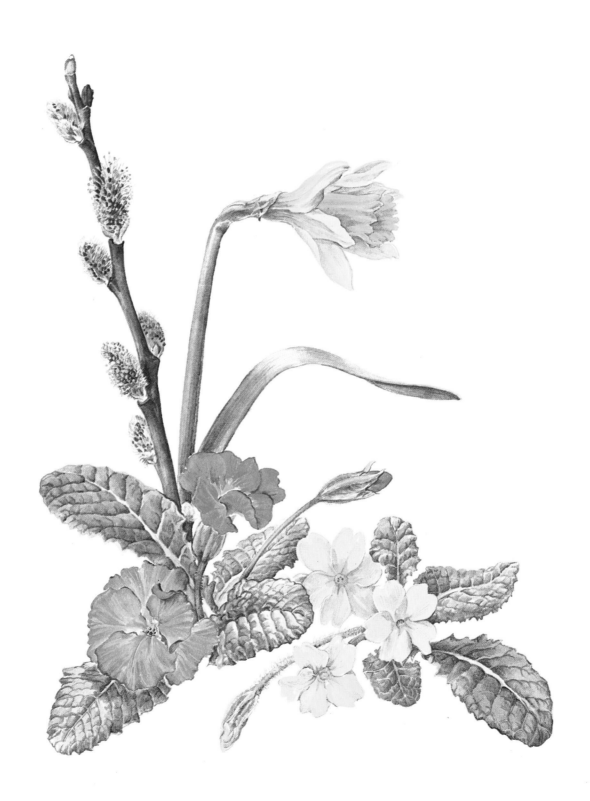

The
flowers
of
January,
February
&
March

The Reawakening

GREEN in light are the hills, and a calm wind flowing
Filleth the void with a flood of the fragrance of Spring;
Wings in this mansion of life are coming and going,
Voices of unseen loveliness carol and sing.

Coloured with buds of delight the boughs are swaying,
Beauty walks in the woods, and wherever she rove
Flowers from wintry sleep, her enchantment obeying,
Stir in the deep of her dream, reawaken to love.

Oh, now begone, sullen care - this light is my seeing;
I am the palace, and mine are its windows and walls;
Daybreak is come, and life from the darkness of being
Springs, like a child from the womb, when the lonely one calls.

walter de la Mare

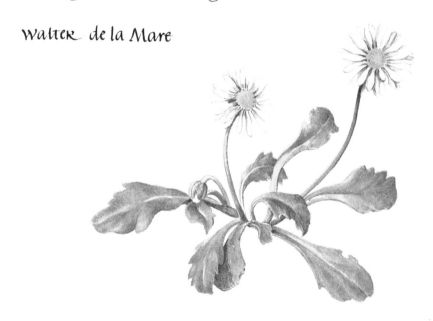

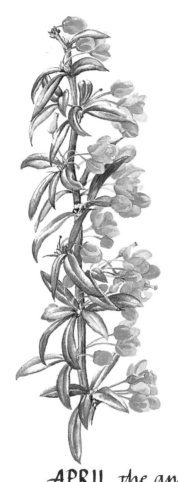

APRIL, APRIL,

Laugh thy girlish laughter;
Then, the moment after,
Weep thy girlish tears!
April, that mine ears
Like a lover greetest,
If I tell thee, sweetest,
All my hopes and fears,
 April, April,
Laugh thy golden laughter;
But, the moment after,
Weep thy golden tears!

 April · William Watson.

APRIL, the angel of the months,
 the young
Love of the year. Ancient and
 still so young
Lovelier than the raven's
 paradox;
Christ's Easter and the Syrian
 Adonis,
When all things turn into
 their contrary
Death into life and silence
 into sound. v. sackville-west.

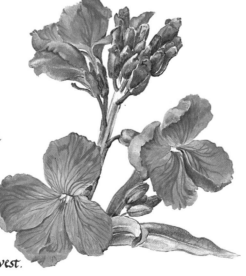

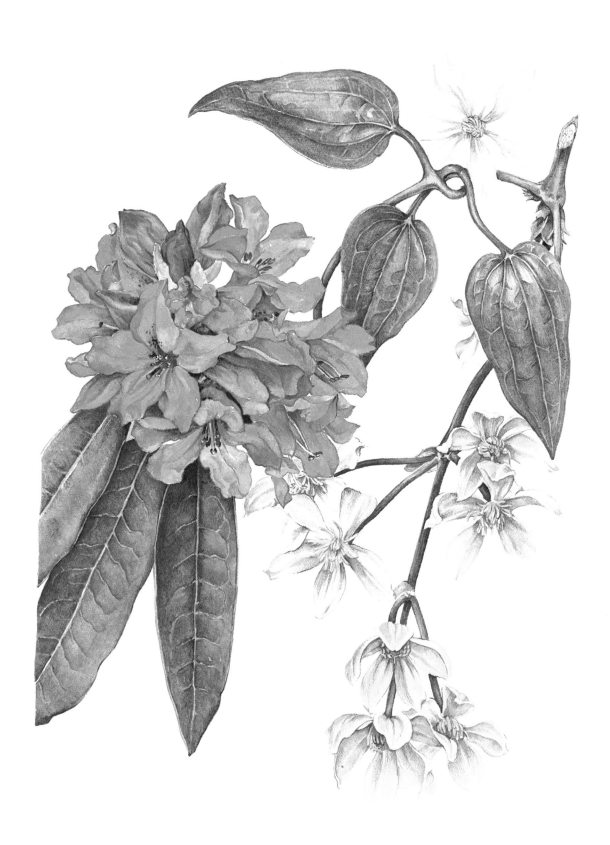

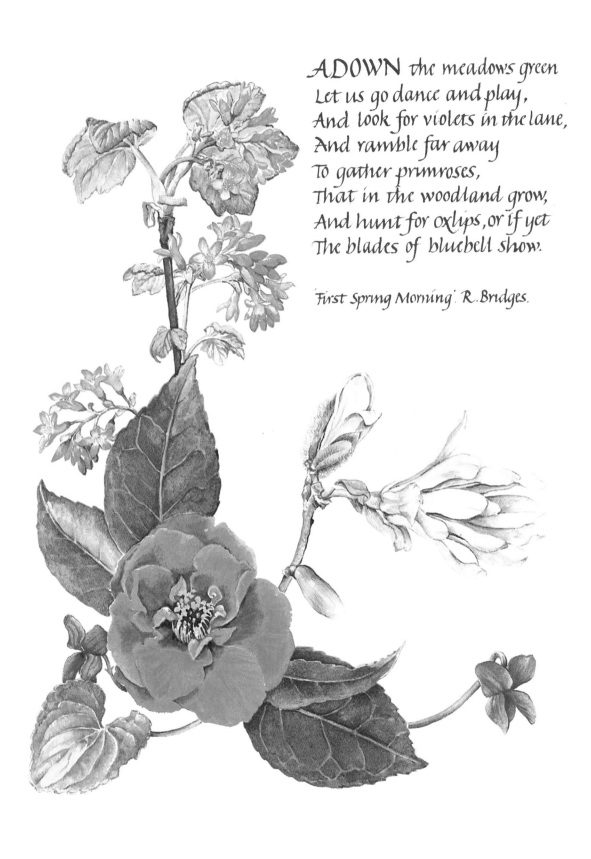

ADOWN the meadows green
Let us go dance and play,
And look for violets in the lane,
And ramble far away
To gather primroses,
That in the woodland grow,
And hunt for oxlips, or if yet
The blades of bluebell show.

First Spring Morning. R. Bridges.

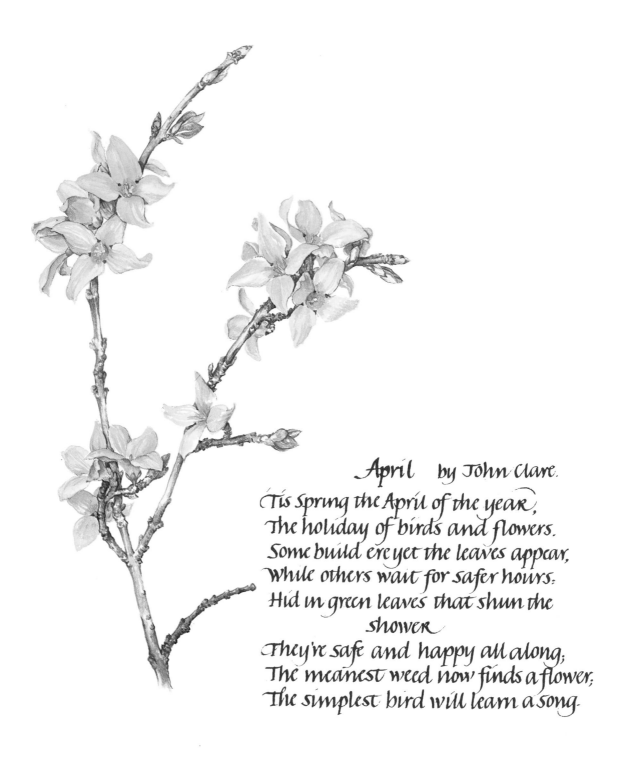

April by John Clare.

Tis Spring the April of the year,
 The holiday of birds and flowers.
 Some build ere yet the leaves appear,
 While others wait for safer hours.
 Hid in green leaves that shun the
 shower
 They're safe and happy all along,
 The meanest weed now finds a flower,
 The simplest bird will learn a song.

TREES

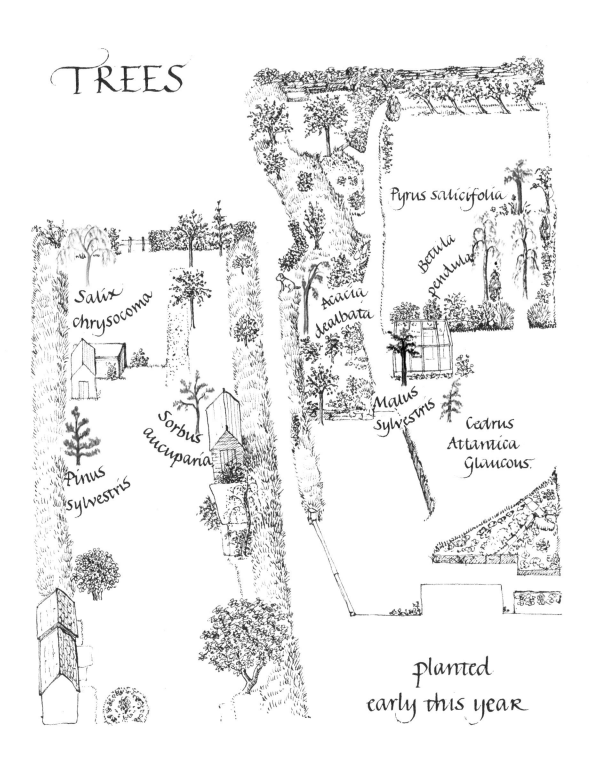

Salix
chrysocoma

Pinus
sylvestris

Sorbus
aucuparia

Acacia
dealbata

Malus
Sylvestris

Pyrus salicifolia

Betula
pendula

Cedrus
Atlantica
Glaucous.

planted
early this year

Sometimes in apple country you may see
A ghostly orchard standing all in white,
Aisles of white trees, white branches, in the green,
On some still day when the year hangs between
Winter and spring, and heaven is full of light.
And rising from the ground pale clouds of smoke
Float through the trees and hang upon the air
Trailing their wisps of blue like a swelled cloak
From the round cheeks of breezes. But though fair
To him who leans upon the gate to stare
And muse 'How delicate in spring they be,
That mobled blossom and that wimpled tree,'
There is a purpose in the cloudy aisles
That took no thought of beauty for its care.
For here's the beauty of all country miles,
Their rolling pattern and their space:
That there's a reason for each changing square,
Here sleeping fallow, there a meadow mown,
All to their use ranged different each year;
The shaven grass the gold the brindled roan,
Not in some search for empty grace,
But fine through service and intent sincere.

'Spring' from The Land, – V. Sackville West.

MAY

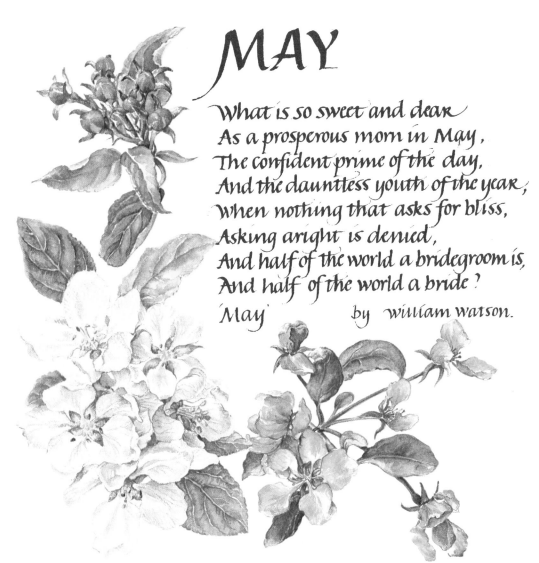

What is so sweet and dear
As a prosperous morn in May,
The confident prime of the day,
And the dauntless youth of the year,
When nothing that asks for bliss,
Asking aright is denied,
And half of the world a bridegroom is,
And half of the world a bride?

'May' by William Watson.

Then broke the spring. The hedges in a day
Burgeoned to green; the drawing of the trees,
Incomparably pencilled line by line,
Thickened to heaviness, and men forgot
The intellectual austerity
Of winter, in the rich warm-blood rush
Of growth, and mating beasts and rising sap.
How swift and sudden strode that tardy spring,
Between a sunrise and a sunset come! (V. Sackville West)

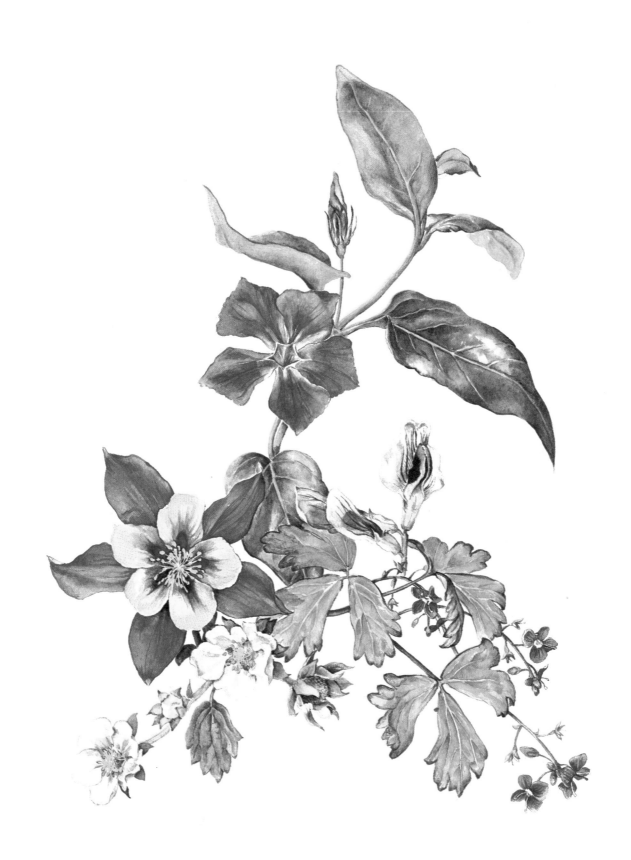

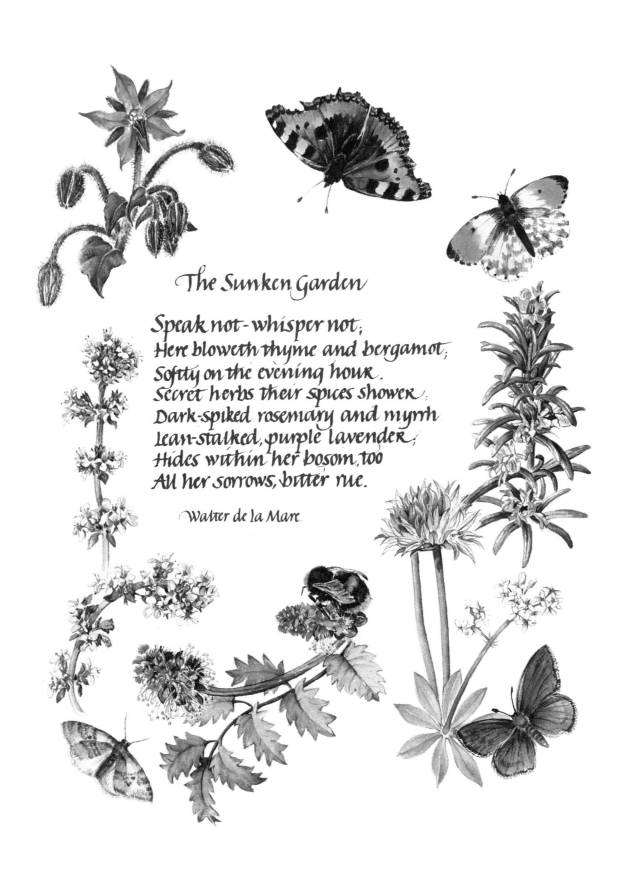

The Sunken Garden

Speak not - whisper not;
Here bloweth thyme and bergamot;
Softly on the evening hour,
Secret herbs their spices shower,
Dark-spiked rosemary and myrrh,
Lean-stalked, purple lavender;
Hides within her bosom, too
All her sorrows, bitter rue.

Walter de la Mare.

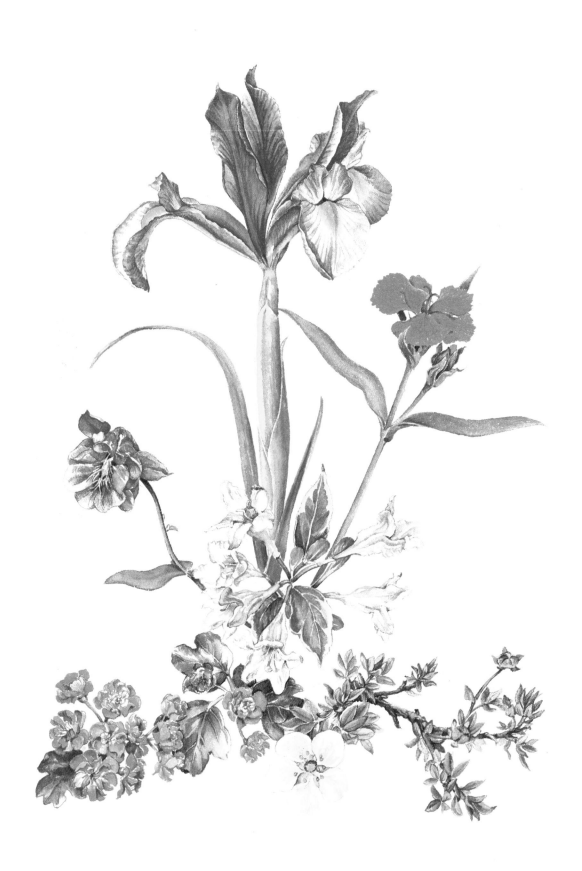

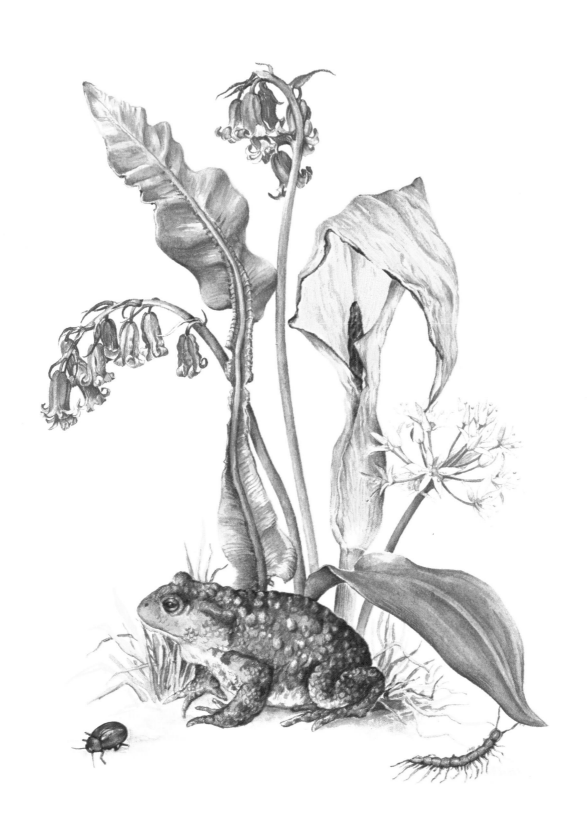

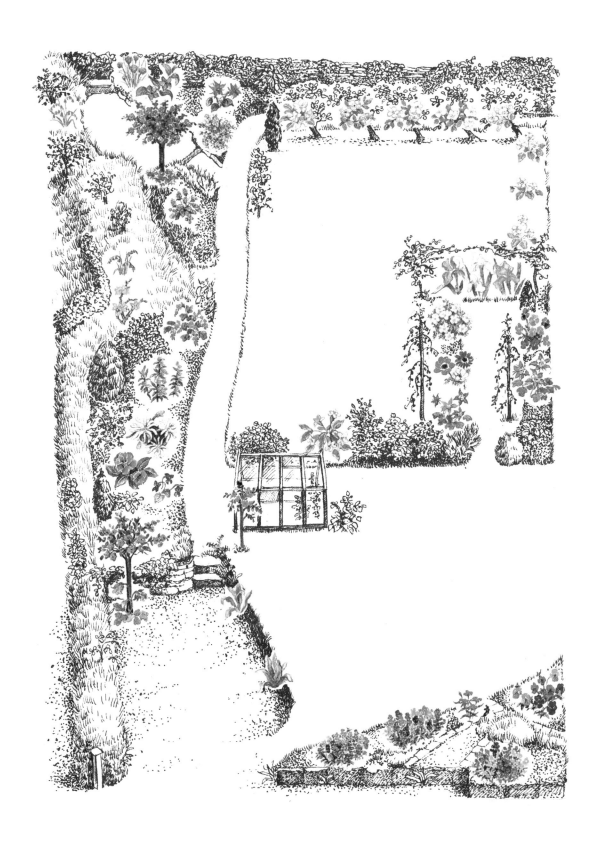

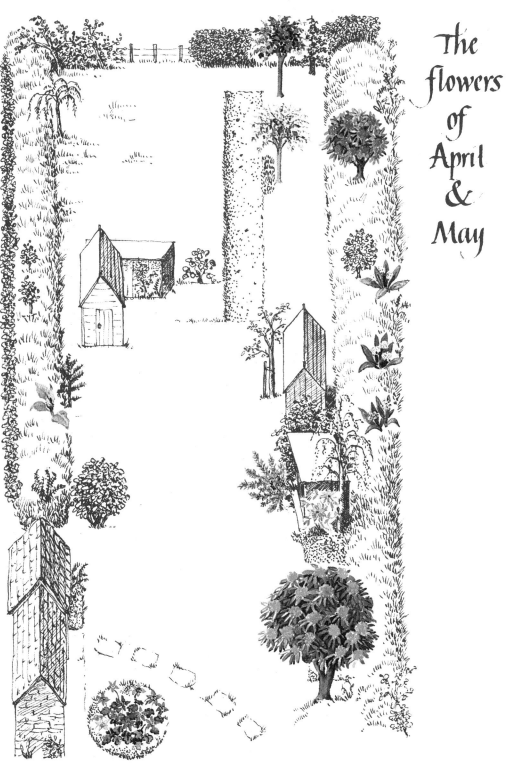

The
flowers
of
April
&
May

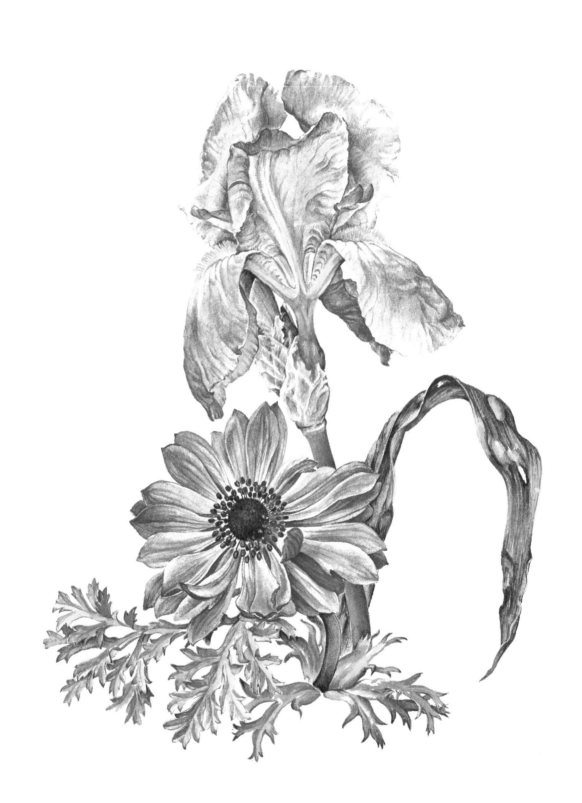

JUNE

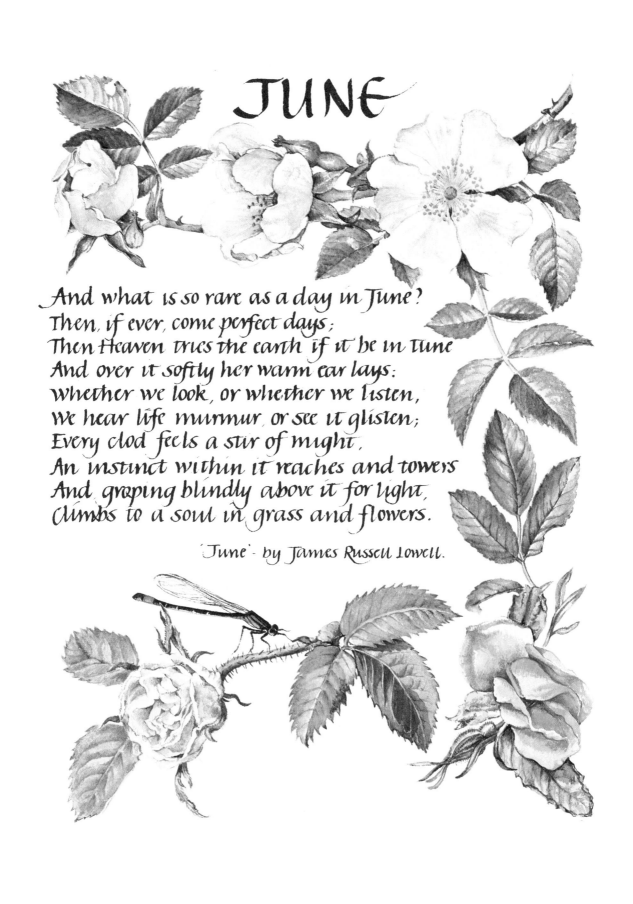

And what is so rare as a day in June?
Then, if ever, come perfect days;
Then Heaven tries the earth if it be in tune
And over it softly her warm ear lays:
whether we look, or whether we listen,
We hear life murmur, or see it glisten;
Every clod feels a stir of might,
An instinct within it reaches and towers
And, groping blindly above it for light,
Climbs to a soul in grass and flowers.

'June'- by James Russell Lowell.

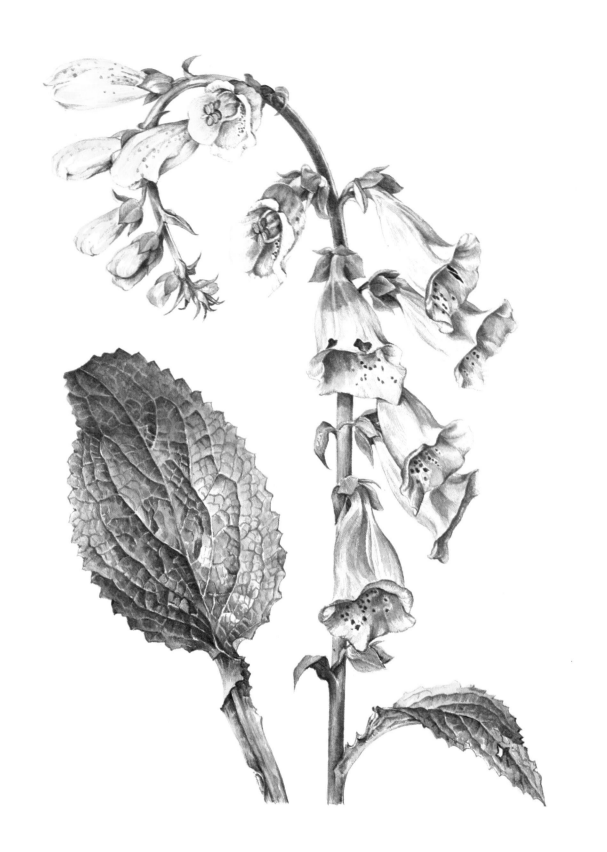

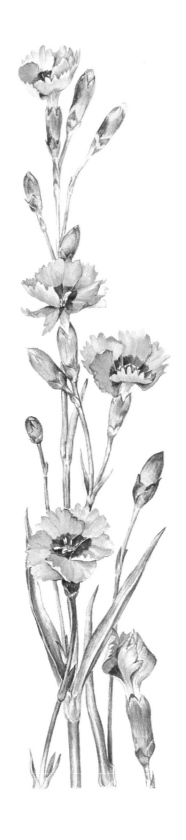

Cheddar Pinks

Mid the squander'd colour
 idling as I lay
Reading the Odyssey
 in my rock-garden
I espied the cluster'd
 tufts of Cheddar pinks
Burgeoning with promise
 of scented bloom
All the modish motley
 of their bloom to-be
Thrust up in narrow buds
 on the slender stalks
Thronging springing urgent
 hasting (so I thought)
As if they feared to be
 too late for summer—
Like schoolgirls overslept
 waken'd by the bell
Leaping from bed to don
 their muslin dresses
 On a May morning.

R. Bridges.

Alas that June should fade;

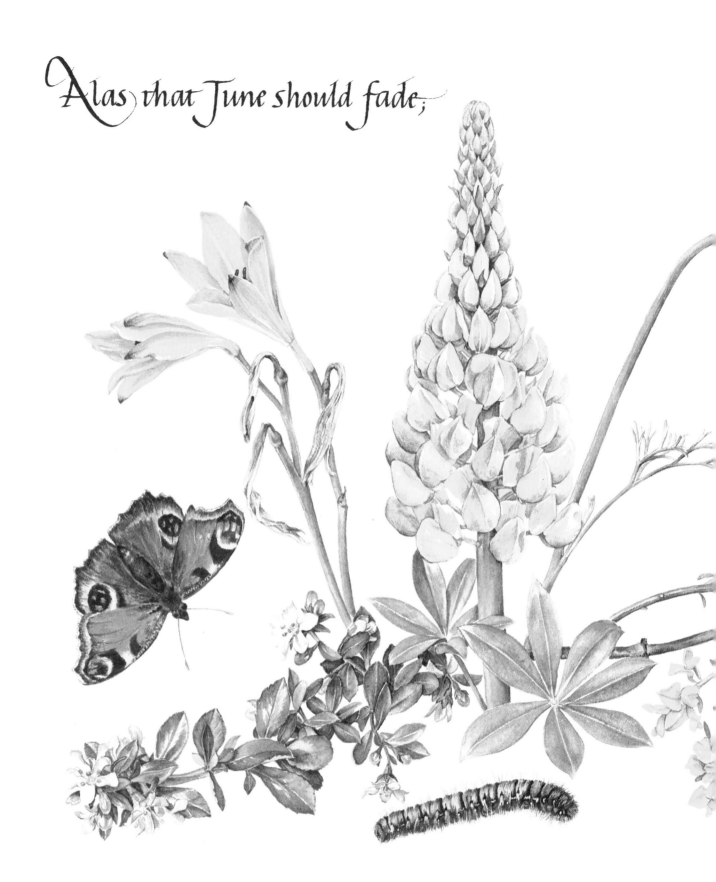

that time should be

So rich yet fugitive a pageantry.

Forsake it then awhile, and with us fly
Into the past where nothing now can die:
Where even the young and lovely, old and staid
Live on unchanged - of purest fantasy made.

Prologue-W.de la Mare.

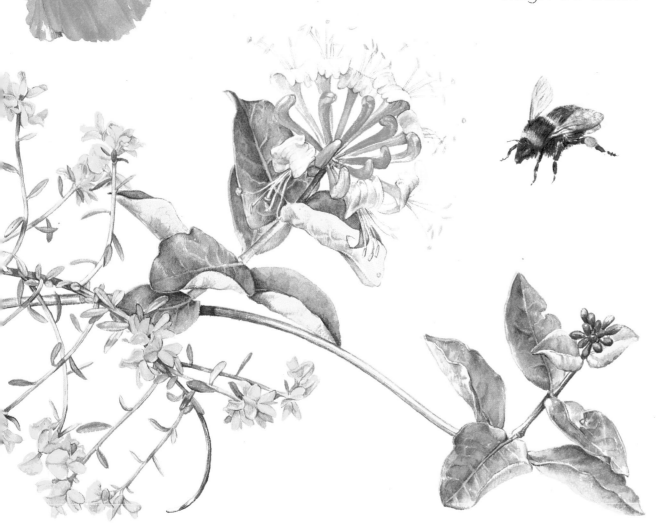

IT MAY indeed be phantasy when I
Essay to draw from all created things
Deep, heartfelt, inward joy that closely clings;
And trace in leaves and flowers that round me lie
Lessons of love and earnest piety.
So let it be; and if the wide world rings
In mock of this belief, to me it brings
Nor fear, nor grief, nor vain perplexity.
So will I build my altar in the fields,
And the blue sky my fretted dome shall be,
And the sweet fragrance that the wild flower yields,
Shall be the incense I will yield to Thee,
The only God: and Thou shalt not despise
Even me, the priest of this poor sacrifice.

To Nature S.T. Coleridge.

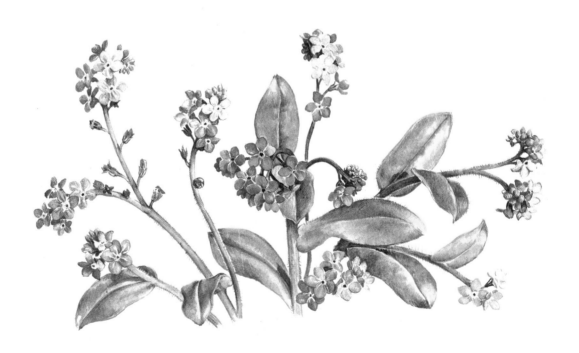

JULY

Heavy is the green of the fields, heavy the trees
With foliage hang, drowsy the hum of bees
In the thund'rous air: the crowded scents lie low
Thro' tangle of weeds the river runneth slow.

July: R. Bridges.

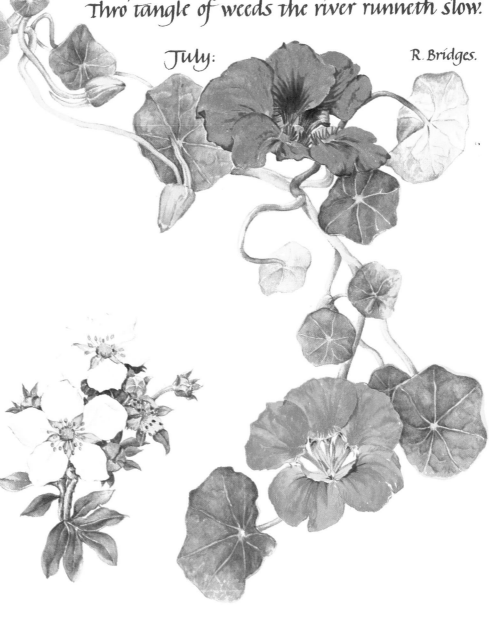

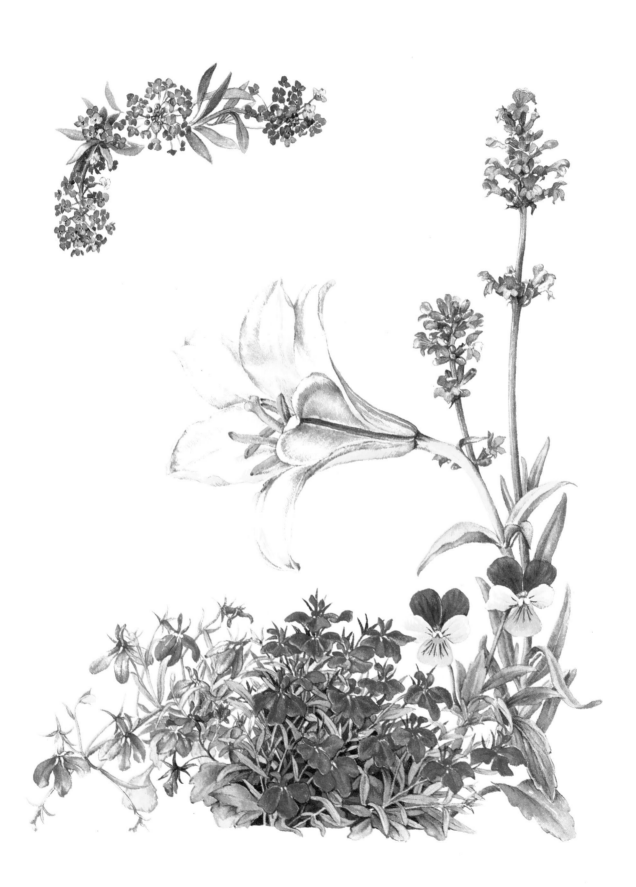

My heart aches, and a drowsy numbness pains
　　My sense, as though of hemlock I had drunk,
Or emptied some dull opiate to the drains
　　One minute past, and Lethe-wards had sunk:
'Tis not through envy of thy happy lot,
　　But being too happy in thy happiness,
　　　　That thou, light-winged Dryad of the trees,
　　　　　　In some melodious plot
　　Of beechen green and shadows numberless,
　　　　Singest of summer in full throated ease.

O for a draught of vintage, that hath been
　　Cool'd a long age in the deep-delved earth,
Tasting of Flora and the country-green,
　　Dance, and Provencal song, and sun-burnt mirth!
O for a beaker full of the warm South,
　　Full of the true, the blushfull Hippocrene,
　　　　With beaded bubbles winking at the brim,
　　　　　　And purple-stained mouth;
　　That I might drink, and leave the world unseen,
　　　　And with thee fade away into the forest dim.

Ode to a Nightingale. - John Keats.

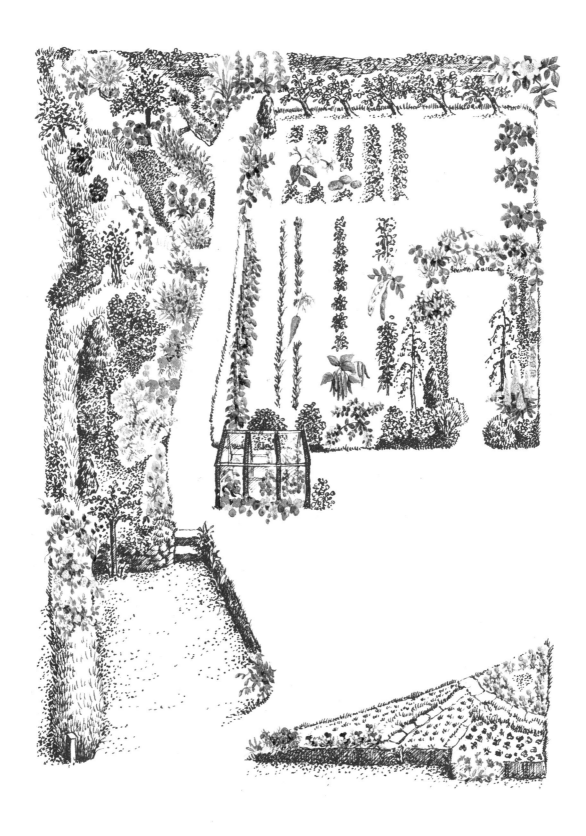

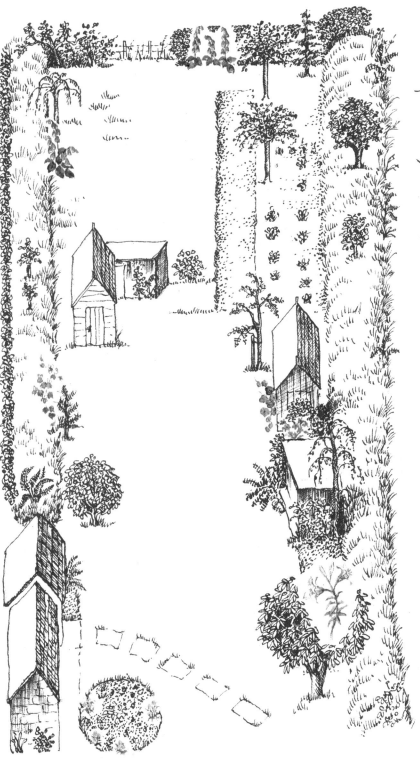

The
flowers
of
June
&
July

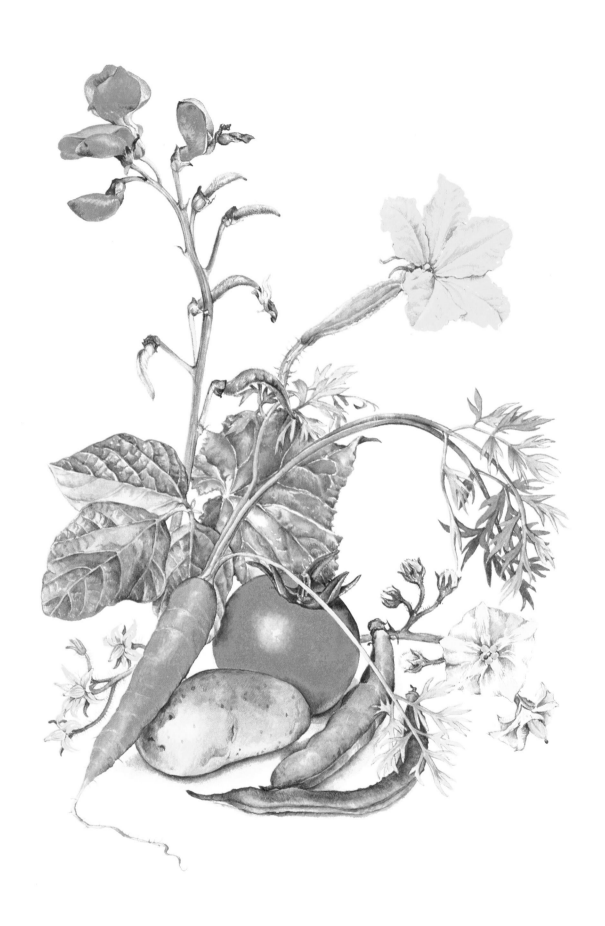

AUGUST

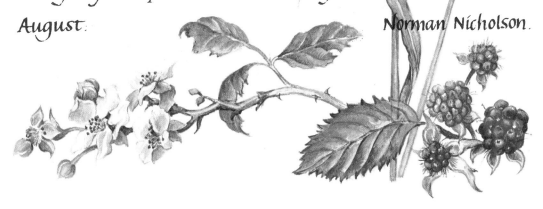

Here the tide of summer thrusts its last
Wave, and ebbs and leaves the white foam stranded
Among the weeds and wagons- white flowers of foam,
Wild carrot and mayweed. The sandstone wall
Dribbles with hanging plants, and the slant
 of the embankment
Is tousled and tussocked with grass. Up tall
Turrets of sorrel the bindweed climbs
Like a spiral staircase, and cinders from the railway
Drift in the one white bell that swings from the top.
Bramble claws among the sleepers and its ruff of petals
Slips from the green berry, and grass and flower and weed,
Topheavy now with seed, are tired and bent.
The fists of the blooms unclinch and let the fruit
Fall from the palm of the hand. And we,
 in a season of work,
Close our eyes, nor count the crown of our labours,
But wait while dark pods form in the brain,
And fingers ripen in the drowse of autumn.

August. Norman Nicholson.

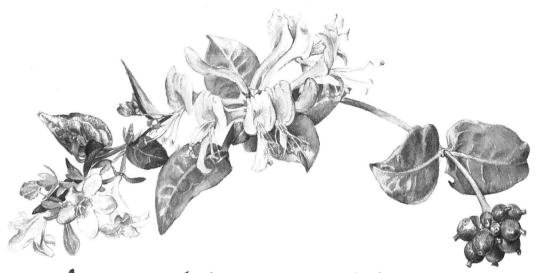

A green and silent spot, amid the hills,
A small and silent dell! O'er stiller place
No singing skylark ever poised himself.

S.T. Coleridge.
from: Fears in Solitude.

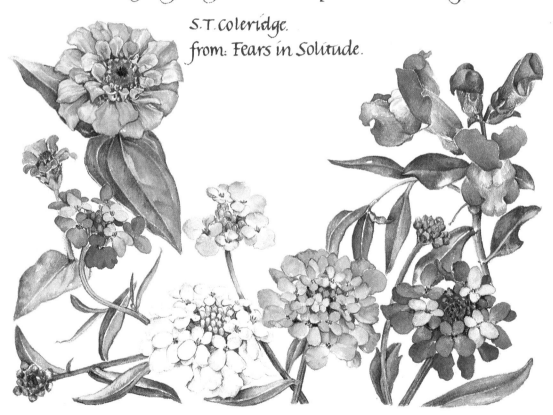

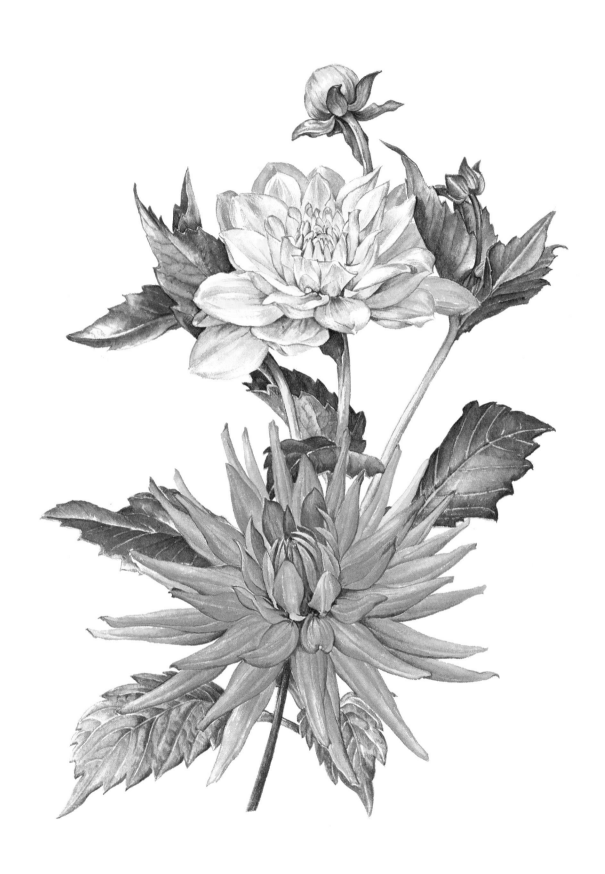

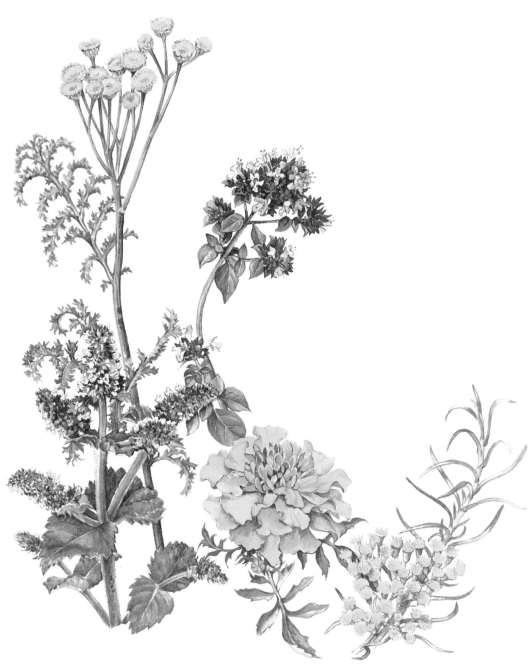

A glance—and instantly the small meek flower
Whispered of what it had to childhood meant;
But kept the angel secret of that far hour
Ere it had lost its scent.

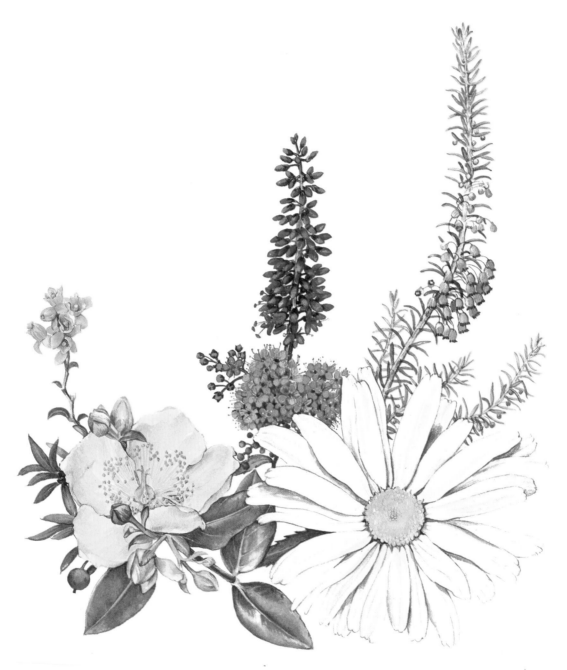

Wraiths that the scented breath of summer raises,
 Ghosts of dead hours and flowers that once were fair
Sorrel of nodding grass and white moon daisies
 Glimmer and fade upon the fragrant air

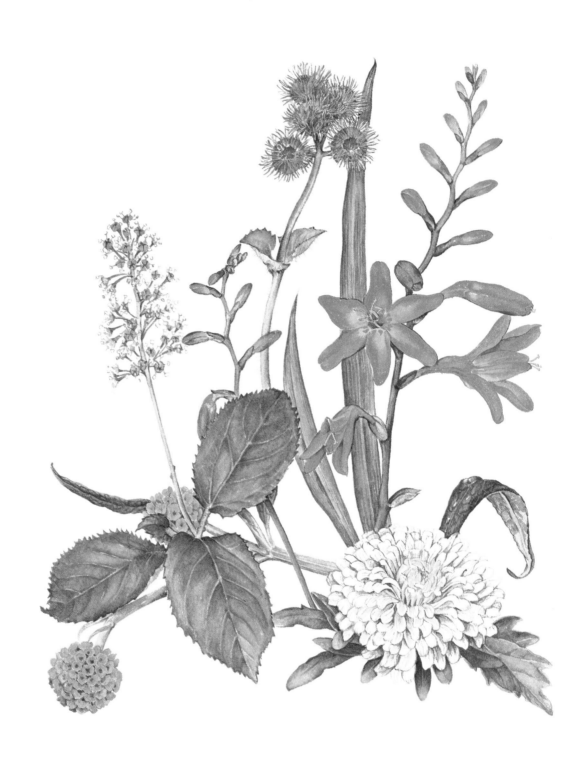

SEPTEMBER

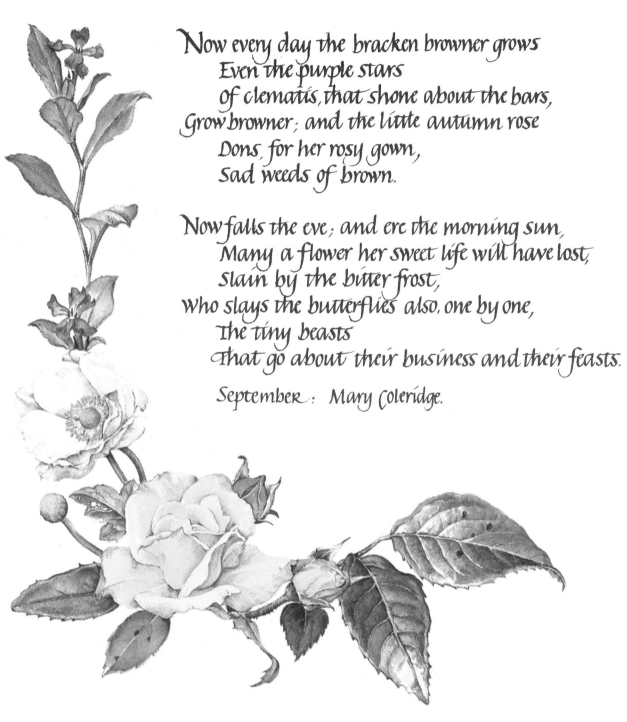

Now every day the bracken browner grows
 Even the purple stars
 of clematis, that shone about the bars,
Grow browner; and the little autumn rose
 Dons, for her rosy gown,
 Sad weeds of brown.

Now falls the eve; and ere the morning sun,
 Many a flower her sweet life will have lost,
 Slain by the bitter frost,
Who slays the butterflies also, one by one,
 The tiny beasts
 That go about their business and their feasts.

September : Mary Coleridge.

Lo! in the middle of the wood,
The folded leaf is woo'd from out the bud
With winds upon the branch, and there
Grows green and broad, and takes no care,
Sun-steep'd at noon, and in the moon
Nightly dew-fed; and turning yellow
Falls, and floats adown the air.
Lo! sweeten'd with the summer light,
The full-juiced apple, waxing over-mellow,
Drops in a silent autumn night.
All its allotted length of days,
The flower ripens in its place,
Ripens and fades, and falls, and hath no toil,
Fast-rooted in the fruitful soil.

from The Lotus Eaters. Tennyson.

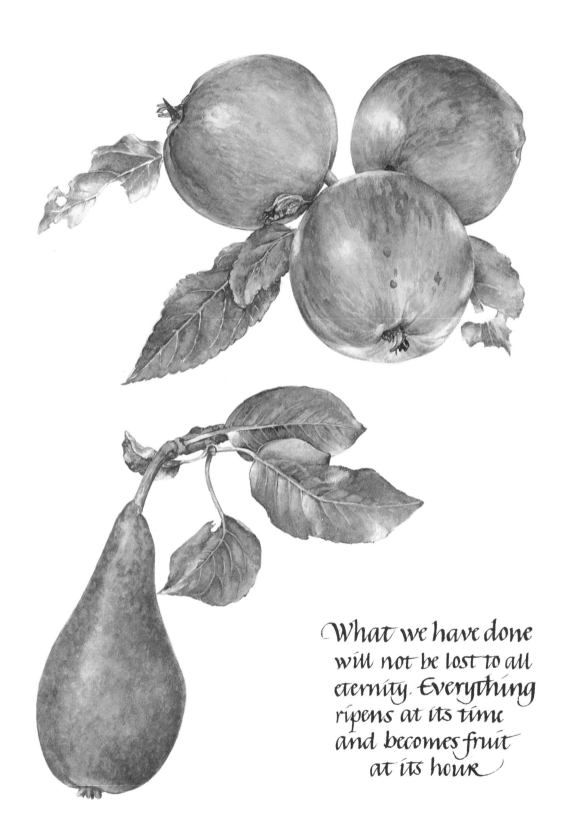

What we have done
will not be lost to all
eternity. Everything
ripens at its time
and becomes fruit
at its hour

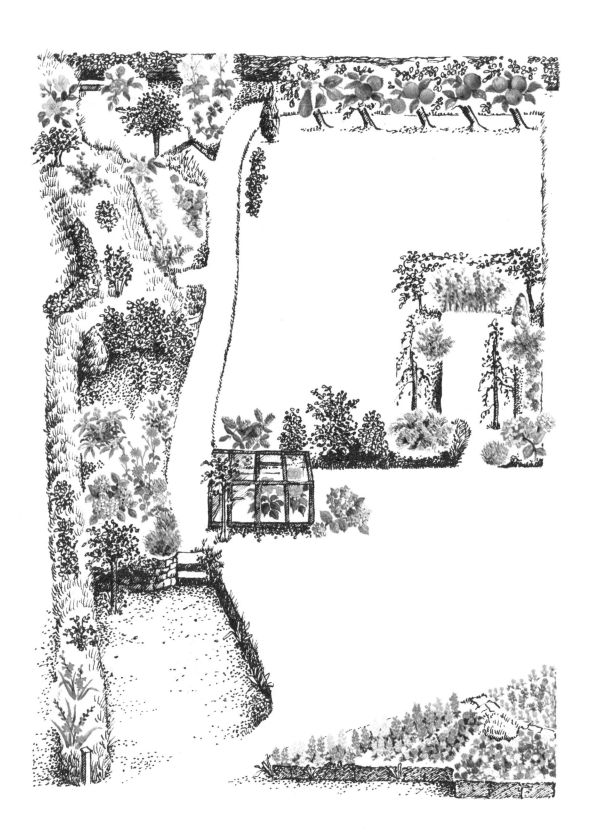

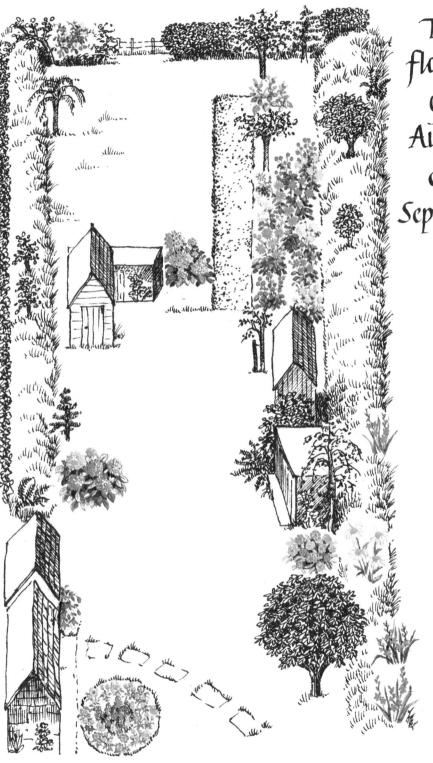

The
flowers
of
August
&
September

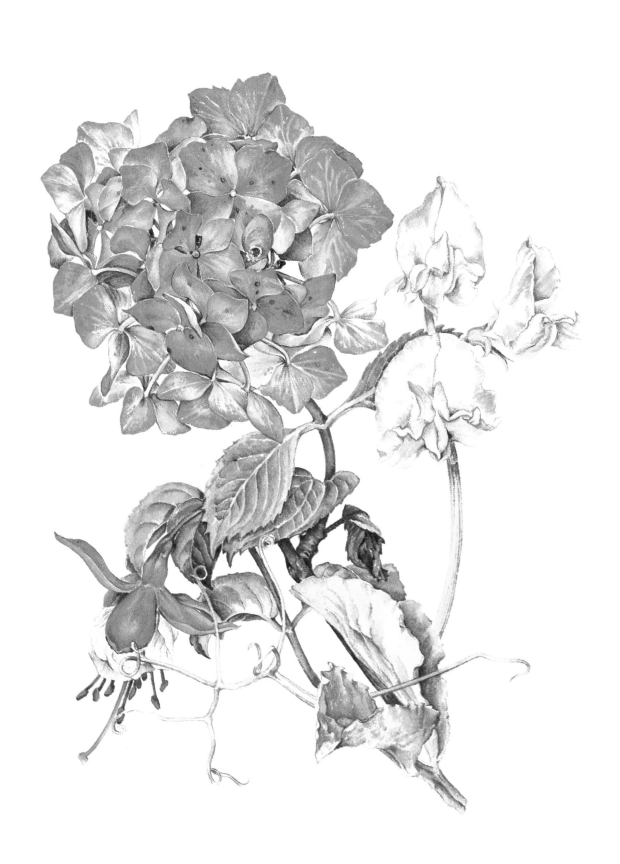

OCTOBER

The green elm with the one great bough of gold
Lets leaves into the grass slip, one by one,—
The short hill grass, the mushrooms small, milk-white,
Harebell and scabious and tormentil,
That blackberry and gorse, in dew and sun,
Bow down to; and the wind travels too light
To shake the fallen birch leaves from the fern;
The gossamers wander at their own will.
At heavier steps than birds' the squirrels scold.
The rich scene has grown fresh again and new
As Spring and to the touch is not more cool
Than it is warm to the gaze; and now I might
As happy be as earth is beautiful,
Were I some other or with earth could turn
In alternation of violet and rose,
Harebell and snowdrop, at their season due,
And gorse that has no time not to be gay.
But if this be not happiness,—who knows?
Some day I shall think this a happy day,
And this mood by the name of melancholy
Shall no more blackened and obscurèd be.

'October' Edward Thomas.

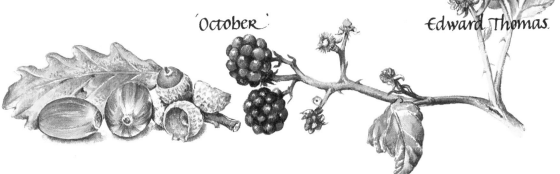

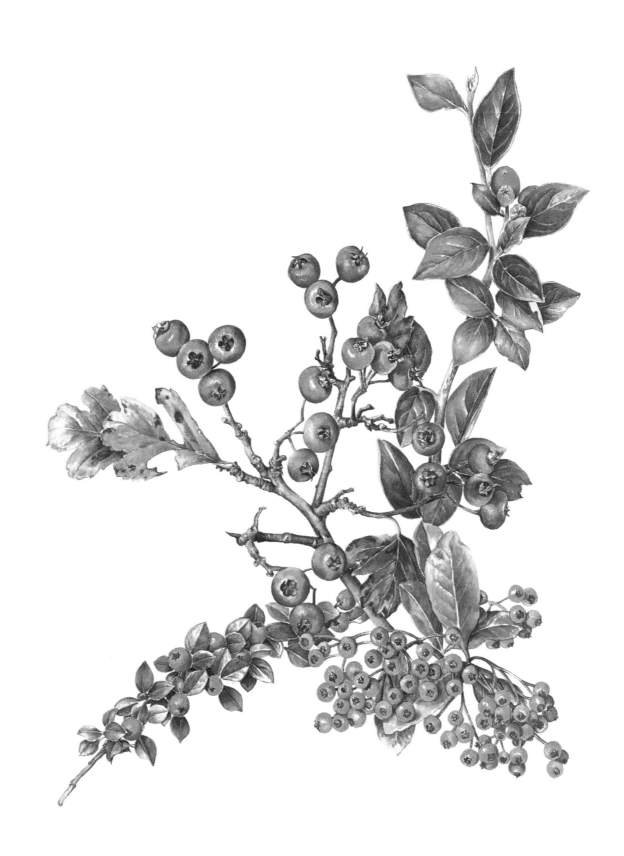

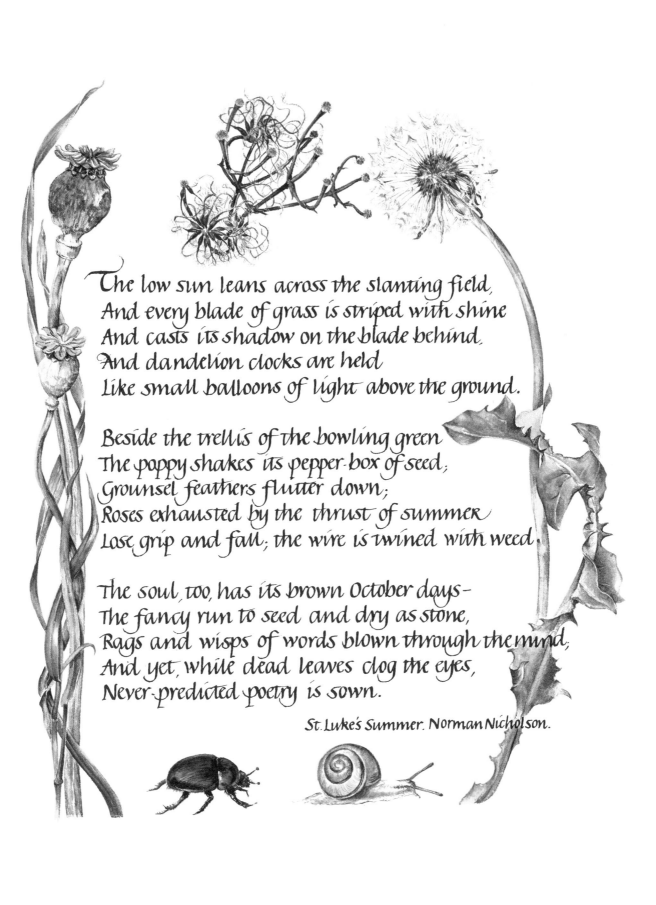

The low sun leans across the slanting field,
And every blade of grass is striped with shine
And casts its shadow on the blade behind,
And dandelion clocks are held
Like small balloons of light above the ground.

Beside the trellis of the bowling green
The poppy shakes its pepper-box of seed;
Grounsel feathers flutter down;
Roses exhausted by the thrust of summer
Lose grip and fall; the wire is twined with weed.

The soul, too, has its brown October days—
The fancy run to seed and dry as stone,
Rags and wisps of words blown through the mind;
And yet, while dead leaves clog the eyes,
Never-predicted poetry is sown.

St. Luke's Summer. Norman Nicholson.

To preserve QUINCE whole

PARE your Quinces very thin and round that they look like a screw; then put them into a well-tinned saucepan with a new pewter spoon in the middle of them, and fill your saucepan with hard water and lay the parings over your Quinces to keep them down: cover your saucepan so close that the steam cannot get out; set them over a slow fire till they are soft, and a fine pink colour; let them stand till they are cold, and make a good syrup of double refined sugar; boil and skim it well; then put in your Quinces; let them boil ten minutes; take them off and let them stand two or three hours; then boil them till the syrup looks thick and the Quinces clear; then put them into deep jars, with brandy-papers and leather over them; keep them in a dry place for use.

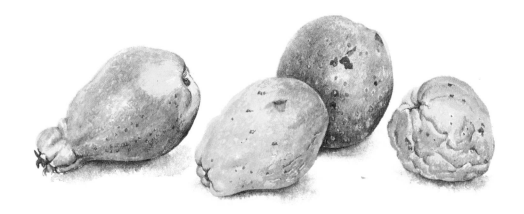

NOVEMBER

The mellow year is hastening to its close;
The little birds have almost sung their last,
Their small notes twitter in the dreary blast—
that shrill-piped harbinger of early snows;
The patient beauty of the scentless rose,
Oft with the morn's hoar crystal quaintly glassed,
Hangs, a pale mourner for the summer past,
And makes a little summer where it grows:
In the chill sunbeam of the faint brief day
The dusky waters shudder as they shine,
The russet leaves obstruct the straggling way
Of oozy brooks, which no deep banks define,
And the gaunt woods, in ragged scant array,
Wrap their old limbs with sombre ivy-twine.

November. by Hartley Coleridge.

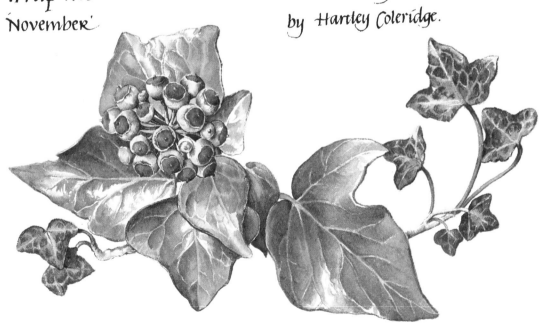

NOW is the time for the burning of the leaves.
They go to the fire: the nostril pricks with smoke
Wandering slowly into the weeping mist.
Brittle and blotched, ragged and rotten sheaves!
A flame seizes the smouldering ruin, and bites
On stubborn stalks that crackle as they resist.

The last hollyhock's fallen tower is dust:
All the spices of June are a bitter reek,
All the extravagant riches spent and mean.
All burns! the reddest rose is a ghost.
Sparks whirl up, to expire in the mist: the wild
Fingers of fire are making corruption clean.

Now is the time for stripping the spirit bare,
Time for the burning of days ended and done,
Idle solace of things that have gone before.
Rootless hope and fruitless desire are there:
Let them go to the fire with never a look behind.
The world that was ours is a world that is ours no more.

They will come again, the leaf and the flower, to arise
From squalor of rottenness into the old splendour,
And magical scents to a wondering memory bring;
The same glory, to shine upon different eyes.
Earth cares for her own ruins, naught for ours.
Nothing is certain, only the certain spring.

The Burning of the Leaves. by Laurence Binyon.

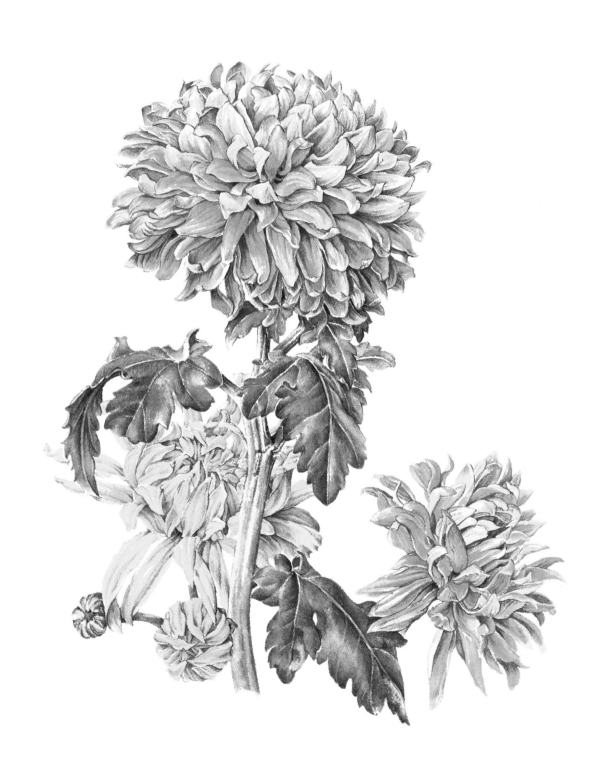

DECEMBER

DEAD lonely night and all streets quiet now,
Thin o'er the moon the hindmost cloud swims past
Of that great rack that brought us up the snow;
On earth strange shadows o'er the snow are cast;
Pale stars, bright moon, swift cloud make heaven so vast
That earth, left silent by the wind of night
Seems shrunken 'neath the gray, unmeasured height.

December by William Morris.

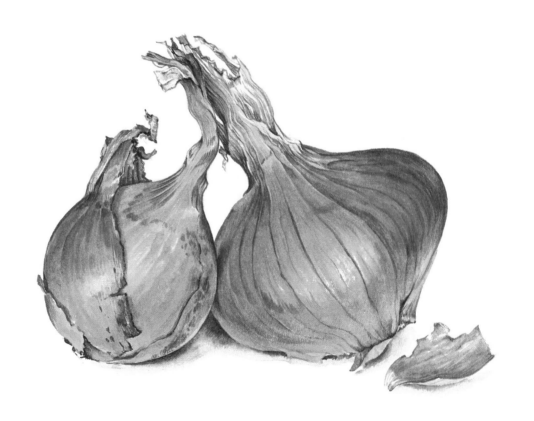

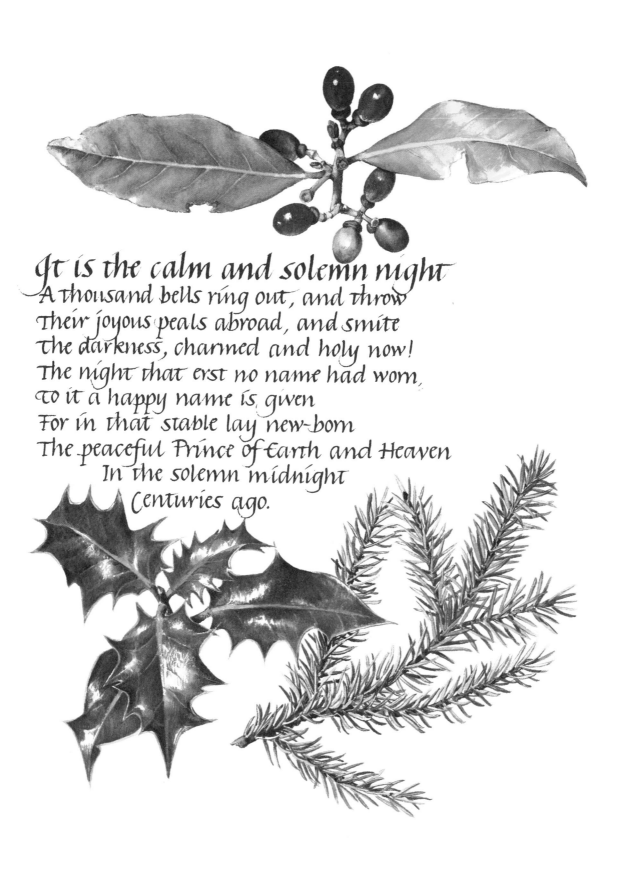

It is the calm and solemn night
A thousand bells ring out, and throw
Their joyous peals abroad, and smite
The darkness, charmed and holy now!
The night that erst no name had worn,
To it a happy name is given
For in that stable lay new-born
The peaceful Prince of Earth and Heaven
 In the solemn midnight
 Centuries ago.

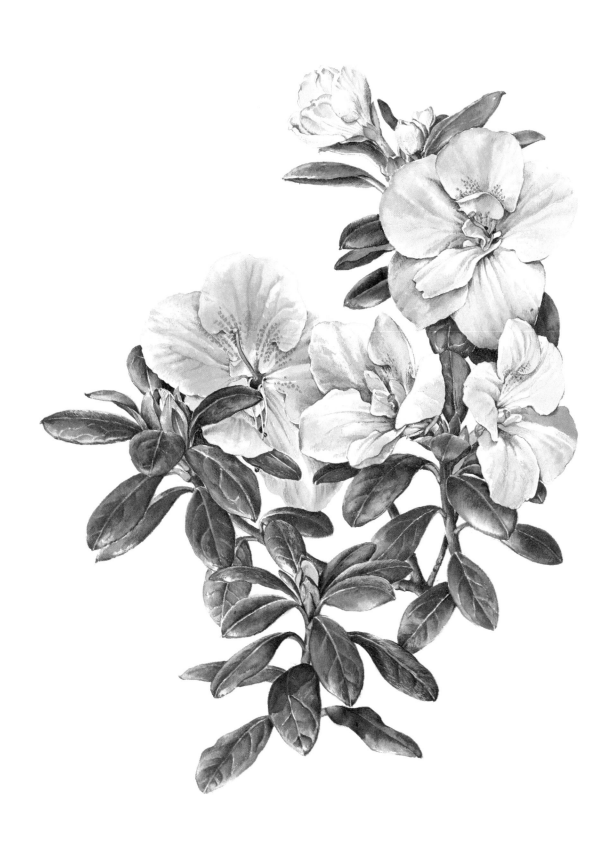

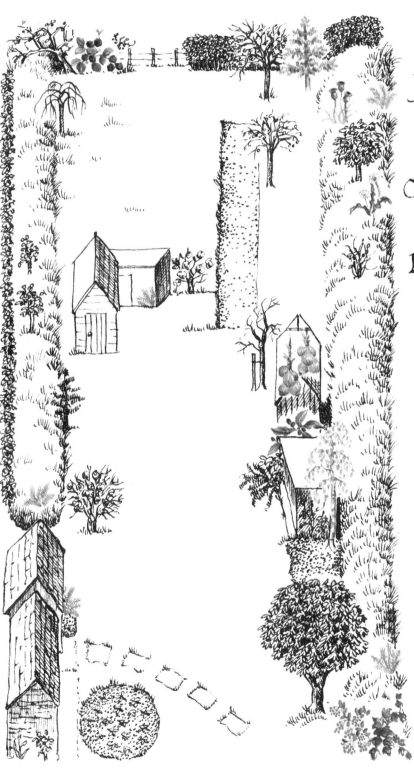

The
flowers
of
October
November
&
December

ONE YEAR
Is sufficient to behold
All the magnificence of nature
Nay, even one day and one night:
For more is but the same brought again;
This sun, that moon, these stars
The varying dance of the spring,
Summer, Autumn, Winter
Is that very same which
The Golden Age
Did see.

GLOSSARY

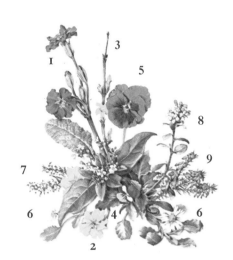

1 **Polyanthus**
Primula x polyantha
Perennial
March–April
ZONE 3

2 **English primrose**
Primula vulgaris
Perennial
March–April
ZONE 5

3 **Winter jasmine**
Jasminum nudiflorum
Hardy deciduous shrub
November–April
ZONE 5

4 **Heartsease**
Viola tricolor
Annual or biennial
April–November
ZONE 4

5 **Garden pansy**
Viola x wittrockiana
Annual or biennial
May–September
ALL ZONES

6 **English daisy**
Bellis perennis
Perennial
All year
ZONE 3

7 **Laurestinus**
Viburnum tinus
Hardy evergreen shrub
November–May
ZONES 7-8

8 *Escallonia*
'Apple Blossom'
Evergreen
Hardy in south
June–October
ZONE 8

9 **Spring heath**
Erica carnea
Hardy evergreen shrub
November–May
ZONE 5

10 **Common snowdrop**
Galanthus nivalis
'Flore pleno'
Perennial bulb
January–April
ZONE 3

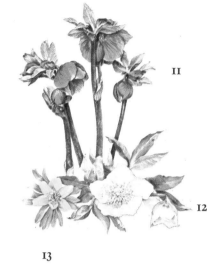

II

12

13

II Lenten rose
Helleborus atrorubens
Hardy evergreen perennial
February–March
ZONE 6

12 Christmas rose
Helleborus niger
Hardy evergreen perennial
December–March
ZONE 3

13 Winter aconite
Eranthis hyemalis
Hardy perennial
February–March
ZONE 4

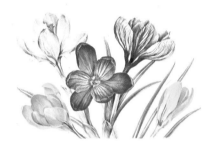

14

14 *Crocus* Dutch hybrids
Hardy perennial
February–March
ZONE 4

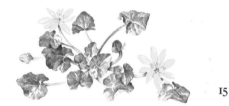

15

15 Lesser celandine
Ranunculus ficaria
Perennial
March–May
ZONE 5

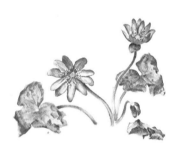

16

16 *Hepatica nobilis*
Hardy perennial
February–April
ZONE 4

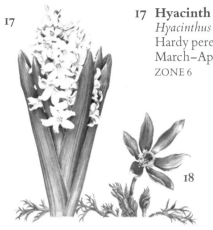

17 Hyacinth
Hyacinthus orientalis hybrids
Hardy perennial bulb
March–April
ZONE 6

18 Pasqueflower
Pulsatilla vulgaris
Hardy perennial
April–May
ZONE 5

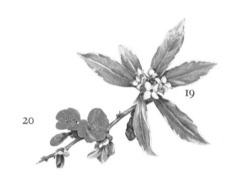

19 Winter daphne
Daphne odora
'Aureomarginata'
Evergreen shrub
Fairly hardy
February–April
ZONE 7

20 Flowering quince
Chaenomeles speciosa
Hardy deciduous shrub
January–April
ZONE 4

21 Goat willow
Salix caprea
Small hardy tree or shrub
March–April
ZONE 4

22 Trumpet narcissus
Narcissus pseudonarcissus
'Lent Lily'
Hardy perennial bulb
Spring
ZONE 4

23 Polyanthus
Primula x polyantha
Perennial
March–April
ZONE 3

24 English primrose
Primula vulgaris
Perennial
March–April
ZONE 5

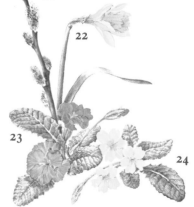

25 English daisy
Bellis perennis
Perennial
All year
ZONE 3

26 Barberry
Berberis x lologensis
Hardy evergreen shrub
March–April
ZONE 7

27 Common wallflower
Cheiranthus cheiri
Hardy biennial
April–June
ALL ZONES

26

27

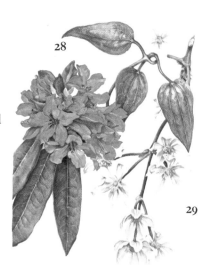

28

28 Tree rhododendron
Rhododendron arboreum hybrid
Evergreen tree
March–May
ZONE 7

29 Armand clematis
Clematis armandii
'Apple Blossom'
Hardy evergreen climber
May–June
ZONE 7

29

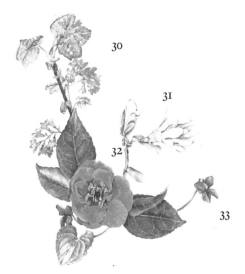

30

31

32

33

30 Red currant
Ribes sanguineum
Hardy deciduous shrub
March–May
ZONE 5

31 Star magnolia
Magnolia stellata
'Rosea'
Hardy deciduous tree
March–April
ZONE 5

32 Common camellia
Camellic japonica
Generally hardy
February–May
ZONE 7

33 Sweet violet
Viola odorata
Hardy perennial
February–April
ZONE 6

34 Border forsythia
Forsythia x intermedia
'Lynwood'
Hardy deciduous shrub
March–April
ZONE 4

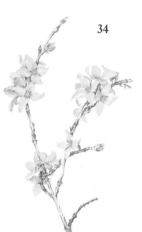

34

35 Pissard plum
Prunus cerasifera
'Atropurpurea'
'Myrobalan'
Hardy deciduous tree
April
ZONE 3

36 Apple blossom in bud
37 Apple blossom
Malus sylvestris
Hardy deciduous tree
Spring
ZONES 3-4
38 Purple crab
Malus x purpurea
Hardy deciduous tree
Spring
ZONE 4

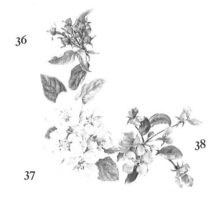

36

38

37

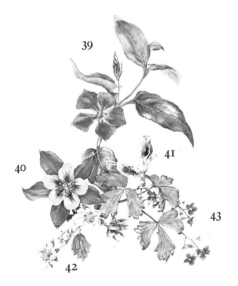

39

41

40

43

42

39 Greater periwinkle
Vinca major
Hardy evergreen sub-shrub
April–June
ZONE 7
40 Columbine
Aquilegia
'McKana hybrid'
Short lived perennial
May–July
ZONES 2-3

41 Broad bean blossom
Vicia faba
Hardy annual
ALL ZONES
42 Strawberry flower
Fragaria x ananassa
Perennial
ALL ZONES
43 Germander speedwell
Veronica chamaedrys
Perennial herb
March–August
ZONE 3

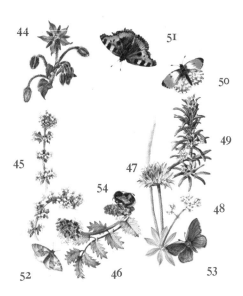

44 Borage
Borago officinalis
Hardy annual
Culinary herb
June–September
ALL ZONES

45 Common thyme
Thymus vulgaris
Hardy aromatic
Woody herb
June
ZONE 5

46 Salad burnet
Sanguisorba minor
Perennial culinary herb
May–September
ZONE 3

47 Chives
Allium schoenoprasum
Hardy perennial
Culinary herb
June–July
ZONES 2-3

48 Sweet woodruff
Galium odoratum
Perennial strewing herb
April–June
BRITISH NATIVE

49 Rosemary
Rosmarinus officinalis
Hardy evergreen
Culinary shrub
March–September
ZONE 6

50 Orange-tree butterfly
Anthocharis cardamines
May–July

51 Small tortoiseshell butterfly
Aglais urticae
April–November

52 Garden carpet moth
Xanthorhoe fluctuata

53 Common blue butterfly
Polyommatus icarus
May–July

54 Bumble bee
Bombus terrestris

55 Dutch iris
Xiphium
'Wedgwood'
Annual
June–July
ZONE 7

56 Chinese Pink or **Indian Pink**
Dianthus chinensis hybrid
Half-hardy annual
July–frost

57 European columbine
Aquilegia vulgaris
Short-lived perennial
May–June
ZONES 2-3

58 *Weigela florida*
'Variegata'
Hardy deciduous shrub
May–June
ZONE 5

59 English hawthorn – flowers
Crataegus laevigata
(Syn. C. oxyacantha)
'Paul's Scarlet'
Hardy deciduous tree
May–June
ZONE 4

60 Bush cinquefoil
Potentilla fruticosa
'Farrer's White'
Hardy deciduous shrub
May–September
ZONE 2

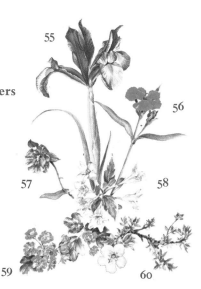

61 English bluebell
Endymion non-scriptus
Hardy perennial bulb
April–June
ZONE 5

62 Hart's-tongue fern
Phyllitis scolopendrium
Evergreen fern
ZONE 3

63 Lords-and-ladies
Arum maculatum
Perennial
April–May
ZONES 7-8

64 Bear's garlic
Allium ursinum
Perennial
April–June
ENGLISH NATIVE

65 Common toad
Bufo bufo
Leaf beetle

67 Centipede
Lithobius sp.

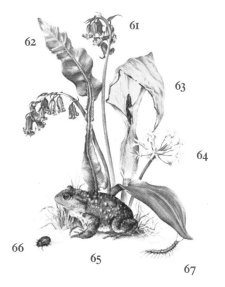

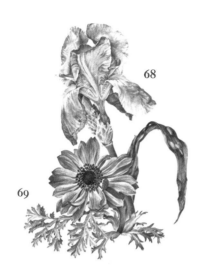

68 Sweet iris
Iris pallida
Hardy bulb
May–June
ZONE 5

69 Poppy anemone
Anemone coronaria
'St Brigid'
Hardy perennial
Spring–summer
ZONE 8

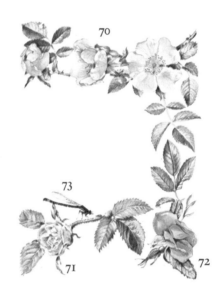

70 Dog rose
Rosa canina
Deciduous shrub
June–July
ZONE 3

71 Cottage rose
Rosa
'Maiden's Blush'
Hardy shrub
June–July
ZONES 4-5

72 Rugosa rose
Rosa rugosa
'Hollandica'
Shrub rose
June–autumn
ZONE 2

73 Damsel fly
Lestes sponsa (male)

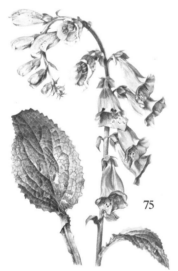

74 Foxglove
Digitalis purpurea
Hardy biennial/perennial
June–July
ZONE 4

75 Allwood pink
Dianthus x allwoodii
'Daphne'
Evergreen perennial
June–July
ZONES 2-3

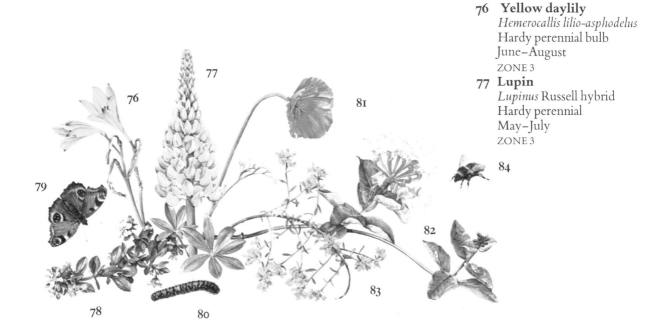

76 Yellow daylily
Hemerocallis lilio-asphodelus
Hardy perennial bulb
June–August
ZONE 3

77 Lupin
Lupinus Russell hybrid
Hardy perennial
May–July
ZONE 3

78 *Escallonia*
'Apple Blossom'
Evergreen
Hardy in south
June–October
ZONE 8

79 Peacock butterfly
Inachis io
June–September

80 Oak eggar caterpillar
Lasiocampa quercus

81 California poppy
Eschscholtzia californica
Hardy annual
June–October

82 Woodbine
Lonicera periclymenum
Hardy deciduous climber
June–September
ZONE 4

83 Broom
Genista lydia
Hardy deciduous shrub
May–June
ZONE 7

84 Bumble bee
Bombus terrestris

85 Forget-me-not
Myosotis sylvatica
Hardy annual or biennial
May–August

86 Nasturtium
Tropaeolum majus
Hardy annual
June–September

87 Bush cinquefoil
Potentilla fruticosa
'Farrer's White'
Hardy deciduous shrub
May–September
ZONE 2

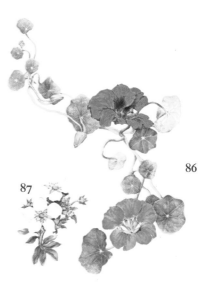

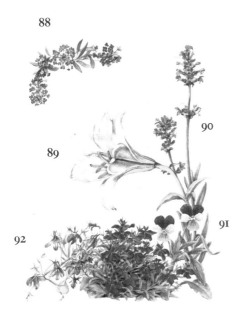

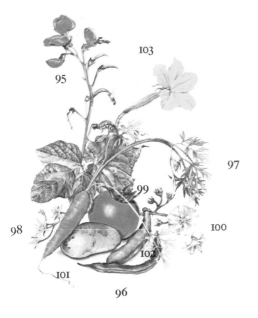

88 Sweet alyssum
Lobularia maritima
(Syn. Alyssum maritimum)
'Wonderland'
'Violet Queen'
Hardy annual
June–September

89 Royal lily
Lilium regale
Hardy bulb
July
ZONE 3

90 True lavender
Lavandula angustifolio
ssp. angustifolia
(Syn. L. officinalis)
Hardy evergreen shrub
July–September
ZONE 5

91 Heartsease
Viola tricolor
Annual or biennial
April–November
ZONE 4

92 Edging lobelia
Lobelia erinus
Half-hardy annual
June–frost

93 Kenilworth ivy
Cymbalaria muralis
Perennial
April–November
ZONE 3

94 Serbian bellflower
Campanula poscharskyana
Hardy perennial
July–September
ZONE 3

95 Scarlet runner bean – flower
Phaseolus coccineus
Tender perennial grown as annual
July–August
ALL ZONES

96 Scarlet runner bean
July–September

97 Garden carrot
Daucus carota
Var. Sativus
Hardy biennial grown as annual
April–October

98 Tomato – blossom
Lycopersicon lycopersicum
Tender or half-hardy annual

99 Tomato – fruit

100 Potato – flower
Solanum tuberosum
Half-hardy perennial grown as annual

101 Potato – tuber

102 Broad bean
Vicia faba
Annual

103 Cucumber – flower and young fruit
Cucumis sativus
Half-hardy annual

104 Wasp
Vespula sp.

105 Bramble – flower and fruit
Rubus
May–November
ALL ZONES

106 Grasses
(a) 'False oat grass'
Arrhenatherum elatius
ZONE 3
(b) Common wild oat
Avena fatua
Annual
ALL ZONES

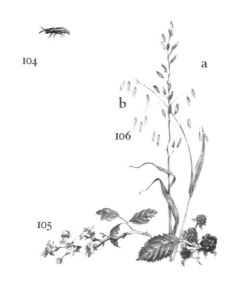

107 Glossy abelia
Abelia x grandiflora
Hardy semi-evergreen shrub
July–September
ZONE 6

108 Woodbine
Lonicera periclymenum
Hardy deciduous climber
June–September
ZONE 4

109 Zinnia
Zinnia elegans
'Peter Pan'
Half-hardy annual
July–September
ALL ZONES

110 Globe candytuft
Iberis umbellata
'Dwarf Fairy Mixed'
Hardy annual
June–September
ALL ZONES

111 Common snapdragon
Antirrhinum majus
Annual
July–frost
ALL ZONES

112 Dahlia
Dahlia hybrid
Formal decorative
Tender tubers
August–frost
ALL ZONES

113 Dahlia
Dahlia hybrid
Cactus type
Tender tubers
August–frost
ALL ZONES

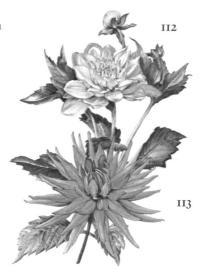

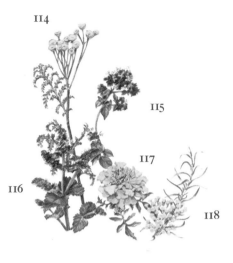

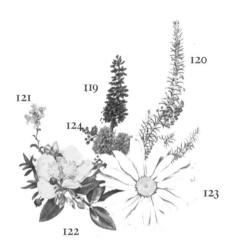

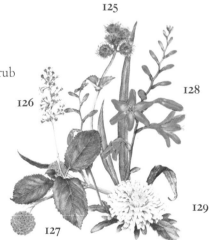

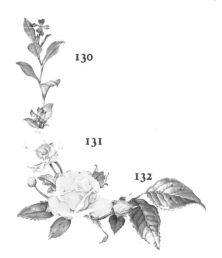

130

131

132

130 Blue ceratostigma
Ceratostigma plumbaginoides
Half-hardy perennial sub-shrub
July–November
ZONES 5-6

131 Japanese anemone
Anemone japonica
Hardy perennial
August–October
ZONE 5

132 Hybrid tea rose
Rosa 'Peace'
Hardy deciduous shrub
June–October
ZONES 6-7

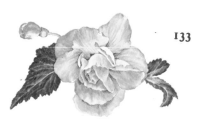

133

133 Tuberous begonia
Begonia x tuberhybrida
Tender perennial
June–September
ZONE 10

136 Hortensia
Hydrangea macrophylla
Deciduous shrub
Hardy in south
July–September
ZONES 5-6

137 Sweet pea
Lathyrus odoratus
Hardy annual
June–September
ALL ZONES

138 Fuschia
Fuschia hybrida
Half hardy
Deciduous shrub
July–October
ZONE 10

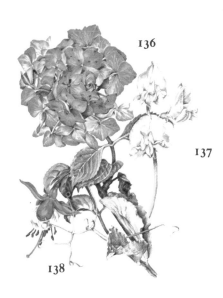

136

137

138

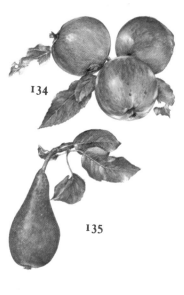

134

135

134 Apple
'Newton Wonder'

135 Pear
'Conference'

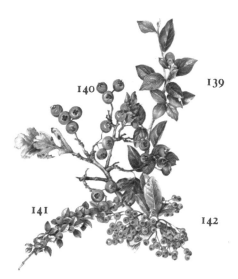

140

139

141

142

139 Franchet cotoneaster
Cotoneaster francheti
Var. sternianus
Hardy semi-evergreen shrub
ZONES 6-7

140 English hawthorn
Crataegus laevigata
Syn. C. oxyacantha
'Paul's Scarlet'
Hardy deciduous tree
Berries – autumn
ZONE 4
(see 59 for flowers)

141 Rock cotoneaster
Cotoneaster horizontalis
Hardy deciduous shrub
Berries – autumn
ZONE 4

142 Scarlet firethorn
Pyracantha coccinea
'Lalandei'
Hardy evergreen shrub
Berries – autumn
ZONES 6-7

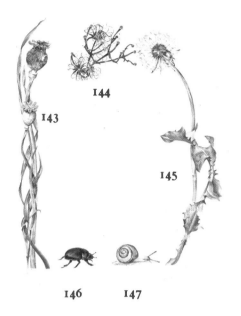

143 **Opium poppy**
Papaver somniferum
Hardy annual or biennial
Flowers – June–August
ALL ZONES

144 **Traveler's joy
or Old-man's-beard**
Clematis vitalba
Hardy climbing shrub
Flowers – July–September
ZONE 4

145 **Dandelion clock**
Taraxacum officinale
Perennial
All year
ZONE 3

146 **Dumble dor**
Geotrupes sp.

147 **Yellow-banded snail**
Cepaea sp.

149 **December moth – male**
Poecilocampa populi

150 **English ivy –** adult and juvenile forms
Hedera helix
Evergreen climber
Flowers – September–November
ZONE 6

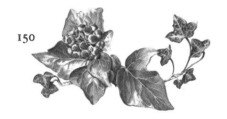

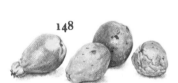

148 **Flowering quince – fruit**
Chaenomeles speciosa
Hardy deciduous shrub
ZONE 4
(see 20 for flower)

(a) Oak
(b) Plum
(c) Strawberry
(d) Hawthorn
(e) Apple
(f) Sycamore
(g) Hawthorn

(h) Rhododendron
(i) Oak
(j) Blackcurrant
(k) Plum
(l) *Clematis armandii*
(m) Apple
(n) Bracken

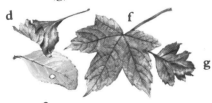

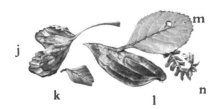

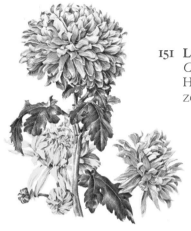

151 Late-flowering chrysanthemums
Chrysanthemum x morifolium
Hardy greenhouse plant
ZONE 5

151

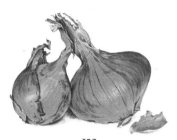

152

152 Onion
Allium cepa
Hardy biennial grown as annual
Summer–autumn
ALL ZONES

153 Sweet bay
Magnolia virginiana
Hardy evergreen shrub
with aromatic leaves
ZONE 7

153

154 English holly
Ilex aquifolium
Hardy evergreen tree or shrub
ZONE 6

155 Norway spruce
Picea abies
Hardy evergreen tree
ZONE 2

155

154

156

156 Indian azalea hybrid
Azalea indica
Pot plant
ZONES 7-8

	ZONE 1	*below 50°*	ZONE 6	*−5° to 5°*
	ZONE 2	*−50° to −35°*	ZONE 7	*5° to 10°*
	ZONE 3	*−35° to −20°*	ZONE 8	*10° to 20°*
	ZONE 4	*−20° to −10°*	ZONE 9	*20° to 30°*
	ZONE 5	*−10° to −5°*	ZONE 10	*30° to 40°*

ACKNOWLEDGEMENTS

The publishers gratefully acknowledge permission to reproduce copyright poems, in whole or in part, in this book.

Laurence Binyon: Lines from 'The Burning of the Leaves' from *The Burning of the Leaves*. Reprinted by permission of Mrs Nicolete Gray and The Society of Authors on behalf of the Laurence Binyon Estate.

Robert Bridges: Lines from 'First Spring Morning', 'January', 'July' from 'The Months', 'Cheddar Pinks', from *The Poetical Works of Robert Bridges*. Reprinted by permission of Oxford University Press.

Walter de la Mare: Lines from 'The Sunken Garden', 'Prologue', 'The Reawakening' and 'A Pot of Musk' from *The Complete Poems*. Reprinted by permission of the Literary Trustees of Walter de la Mare and the Society of Authors.

Norman Nicholson: Lines from 'St Luke's Summer' and 'August' from *Rockface*. Reprinted by permission of Faber & Faber Ltd.

Alfred Noyes: Lines from 'The Remembering Garden' from *The Collected Poems*. Reprinted by permission of John Muray (Publishers) Ltd. and Hugh Noyes.

V. Sackville-West: Lines from 'The Land' from *Collected Poems*, published in the U.S. by Doubleday & Co. Reprinted by permission of William Heinemann Ltd. and Curtis Brown Ltd. Copyright © 1934 by V. Sackville-West. Lines from *The Garden*, published in the U.S. by Doubleday & Co. Reprinted by permission of Curtis Brown Ltd. Copyright © 1946 by V. Sackville-West.

Muriel Stuart: 'The Seed Shop' from *Selected Poems*. Reprinted by permission of the Executors of the Muriel Stuart Estate and Jonathan Cape Ltd.

Bayard Taylor: Lines from 'March' from *The Floral Year* by L. J. F. Brimble. Reprinted by permission of Macmillan London and Basingstoke.

Edward Thomas: 'Celandine', 'First Known When Lost' and 'October' from *Collected Poems*. Reprinted by permission of Faber & Faber Ltd. and Myfanwy Thomas.

Rosamund M. Watson: Lines from 'The Lamp and the Lute'. Reprinted by permission of The Bodley Head.

Sir William Watson: Lines from 'April' and 'Ode in May' from *The Poems of Sir William Watson*. Reprinted by permission of George G. Harrap & Company Ltd.